IMAGES
of America

THE JEWISH COMMUNITY OF
WEST PHILADELPHIA

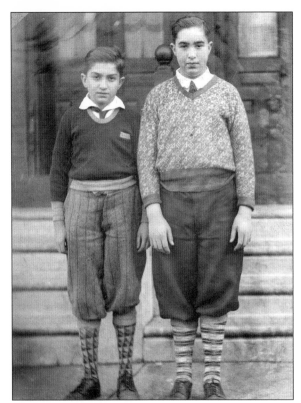

Left: My father, Leonard Meyerowitz (of blessed memory), came to West Philadelphia with his brother Samuel and sister Jean from the farms of upper Montgomery County in East Greenville along Route 29 in the late 1920s. Leonard, the son of Elsie and Eleck Meyerowitz, lived at 4227 Wylausing Avenue near Belmont and Girard Avenues. The family survived the Great Depression by selling farm products from the countryside to people in the neighborhood. *Right:* My father-in-law, Robert (Sidney) Manusov, the son of Morris and Ethel, grew up at 4123 Poplar Streets, right around the corner from my father, a short walk over the Forty-second Street railroad bridge, in the 1930s and 1940s. Both men had similar experiences in the community, such as visiting Fairmount Park, delivering newspapers, and going to the wonderful Philadelphia Zoo only blocks away at Thirty-fourth Street and Girard Avenue.

Dedicated in loving memory of my mother-in-law, Gloria Manusov, who came to the Passover Seder at our house and actually asked to see the proof copy of this book. Gloria passed away on April 21, 2001.

On the cover: Many family affairs marking major Jewish events took place at the Wynne (Uhr's) Caterers in Wynnefield. The bar mitzvah of Joel Ravitch, son of Toby and Sidney, at Tikvas Israel gave Bubbie Goldie (Toby's mother) and the cantor Zayde Phillip Radvitch (from 5735 Pemberton Street and) much *naches* (happiness) in the 1960s. Joel's sister Nina joined in the fun when her mother enjoyed a piece of the elaborate bar mitzvah cake, symbolizing the old Temple in Jerusalem. (Courtesy of Toby and Sidney Ravitch.)

IMAGES
of America

THE JEWISH COMMUNITY OF
WEST PHILADELPHIA

Allen Meyers

ARCADIA

First printed in 2001.

Published by Arcadia Publishing,
an imprint of Tempus Publishing, Inc.
2A Cumberland Street
Charleston, SC 29401

Printed in Great Britain.

Library of Congress Catalog Card Number: 2001088730

For all general information contact Arcadia Publishing at:
Telephone 843-853-2070
Fax 843-853-0044
E-Mail sales@arcadiapublishing.com

For customer service and orders:
Toll-Free 1-888-313-2665

Visit us on the internet at http://www.arcadiapublishing.com

The author's dear friends Bettyanne (Abramson) and Donald Gray are shown here. Bettyanne grew up at 1612 South Fifty-seventh Street, directly across from the famous Phil's Luncheonette in Southwest Philadelphia, in the 1940s and early 1950s. Bettyanne's father, who owned a barbershop that was originally in South Philadelphia, migrated to a better neighborhood, Southwest Philadelphia. Bettyanne graduated West Philadelphia High School in 1952 and, in 1957, married her sweetheart, Donald Gray of Strawberry Mansion. The marriage was performed by Rabbi Morris Goodblatt at Beth Am Israel, a neighborhood synagogue. Their wedding portrait by Claire Pruett, a popular photographer from Fifty-second and Market Streets, is a constant reminder of that special day in 1957. Bettyanne met the author at Gratz Hebrew College while taking courses in the 1970s. Their friendship has spanned more than 25 years. The Grays' commitment to Jewish life and community service inspired the author to turn his original synagogue research into several volumes on Jewish community history throughout Philadelphia.

CONTENTS

Acknowledgments 6

Introduction 7

1. Hidden History 9

2. Bridges Across the Schuylkill River 15

3. Two Fares for Fifteen Cents 19

4. Our Neighborhoods, Our Families 29

5. Schools 43

6. Fun and Recreation Time 55

7. The Business Districts 65

8. Neighborhood Synagogues 83

9. World War II Heroes 99

10. Boychicks and Mavens Grown Up 107

11. Lifelong Friendship Groups 117

ACKNOWLEDGMENTS

My father, Leonard Meyerowitz (of blessed memory), came to live in West Philadelphia at 4227 Wyalusing Avenue, near Fortieth Street and Girard Avenue, with his family in the late 1920s from the countryside in the upper reaches of Montgomery County. He was born in 1918, the son of Elsie and Eleck, an American Jewish farmer in East Greenville, near Quakertown, Pennsylvania. The extended family included grandparents Max and Cecelia Meyerowitz, who had eight children: my grandfather Eleck, Tobias, Sam, Louis, Conrad, Shim, Tille, and Esther.

From the 1890s through the 1920s, Max gave each son a farm in the community, hoping to provide for them a successful future.

Their migration back to Philadelphia in the late 1920s and during the Great Depression was a matter of survival for the Meyerowitz family. The egg route started by Eleck and his brother Shim brought fresh farm products to West Philadelphia. In addition, Eleck selected the area in West Philadelphia for a home in order to be close to his mother-in-law's family (the Taylors, originally from Fourth and Federal Streets in South Philadelphia), who settled on Belmont Avenue below Girard Avenue. The era of relatives living close to each other marked the early immigration period throughout Philadelphia and among many ethnic groups.

A unique piece of family history surfaced before the passing of Elsie Meyerowitz. When I asked my grandmother for the names of her parents, she told me they were Max and Cecelia. That did not sound right because one set of my great-grandparents were already named Max and Cecelia. According to Jewish custom, the rabbi could not marry my paternal grandparents because if one of the couple's parents passed away, they could not name their newborn for that person, as it would violate Jewish naming customs, yet in this case there was still one person living with the same name. The old-world traditions were put aside and the marriage took place in Allentown in 1917 and, thankfully, during the childbearing years of the marriage, the parents and in-laws remained healthy and alive.

My family heritage interconnected here, too. I met my wife, Sandy Manusov, in the autumn of 1982. Sandy's father, Bob (originally Sidney, but he so despised his name that he changed it) Manusov, lived at 4123 Poplar Street, a short walk from my father, Leonard, at 4227 Wyalusing Avenue. It was a short distance to Fairmount Park and the delicatessens, bakeries, and general shopping on Fortieth Street or Girard Avenue, separated only by the Forty-second Street Pennsylvania Railroad bridge. This allowed each member of the community to experience these parts of the neighborhood. The extended Manusov family operated the first self-serve supermarket, a double store located at Fortieth Street and Lancaster Avenue.

When Jewish people get together they often engage in "Jewish geography," or a question-and-answer session where one person asks, "Where did you grow up?" and "Do you know this or that person?" Mine and Sandy's families were interconnected through close proximity in various neighborhoods throughout different periods of the 20th century, since both families had migrated to Northeast Philadelphia before the end of World War II. In fact, the Meyerowitz family moved to Gransback Street off Roosevelt Boulevard and were neighbors of Sandy's maternal grandparents—Sam and Anna Gendleman. Old-world traditions did not get lost—this was *Bershert*, the term for divine will.

This volume is a tribute to my paternal grandmother, Elsie Meyerowitz, who lived to the age of 93, witnessed my marriage to Sandy, and held her precious granddaughter Alisha Rochelle Meyers. Elsie often commented to me, "You had to grow up somewhere."

—Allen Meyers
Eruv Purim
March 7, 2001

INTRODUCTION

The author took out an advertisement in the *Jewish Exponent* to advertise for photographs from the community to illustrate this volume. Hundreds of people responded with letters, postcards, photographs, faxes, and e-mails. This volume covers seven neighborhoods surrounding West Philadelphia proper. This book is a collage that could represent anyone's family; people have many photographs with similar poses in front of the same institutions, but the faces are different. Thelma Cohen Bell, who currently lives in Florida, best represents the flavor of the mid-20th century, when Jewish life flourished in West Philadelphia. She lived in West Philadelphia from 1936 to 1956.

"I lived in the dwelling portion of the candy store my father owned and operated at 56th and Addison Street near the Addison Bakery. I attended Holmes Junior High School and later went to West Philadelphia High School. . . . I graduated in 1942. How well I remember the 56th Street movies, up the street at 56th and Larchwood Avenues. The nearby stores included Satins, Wagner's Tailor Shop, Rotman Produce, Goldstein's Grocery, and Phil Wishnefsky Kosher Butcher shop. On 56th Street, the Sherwood Recreation Center provided free swimming lessons in its pool, but one summer it was closed quite often due to the fear [of] an Infantile Paralysis epidemic. On 60th Street, I remember Benny's Poolroom, where my younger brother Stanley Cohen was a frequent participant, along with many other boys from the neighborhood who ranged in ages from 10 to 16. Also, on 60th Street was Barson's Luncheonette, which was extremely popular for their waffles and ice cream. Another moviehouse was the Imperial. Additional stores included Saylor's butter and eggs and Olga Dorfman, who sold fancy women's clothing. Then there was the Pink shop for hats, Joy Hosiery, Moskowitz bakery, Dash's Deli and Knishes, and Gilbert's poultry, where live chickens were killed while you waited . . . kosher of course. Next there was Regal Lamps, Conick's homemade candy store, Kaplan's shoes, Levins's drugstore, A–Z hardware, the American and New York Bargain Shops, and dozens more shops. On 63rd Street, at Ludlow Street, across from Cobbs Creek Park, was the West Philadelphia Jewish Community Center. The next block going south featured the dominant Walnut Park Plaza Hotel and apartment complex, where bar mitzvahs, weddings, and Jewish affairs were regularly held.

"Further down 63rd Street, as it snaked its way along Cobbs Creek, [the area opened up to what was] known as the Hollow, which contained tennis and basketball courts and loads of picnic tables. Going down Market Street, the Crosskey Movies at 59th Street. How can anyone forget the Arena at 46th Street? Many boxing matches were held there and the facilities hosted the Philadelphia Warriors, [a] National Basketball Association team, which later became the Philadelphia 76ers. An iceskating rink drew a large crowd of people to the arena on Sundays, and who could forget that Dick Clark hosted the acclaimed, *American Bandstand*, where teenagers spent their after school hours dancing while being televised nationally. Many people who congregated at the homes of the lucky families who had purchased their first TV [could enjoy television] before the prices [of the sets] were [made] more affordable for the masses. On Tuesday nights, the ritual was to see the Texaco-sponsored Milton Berle Comedy hour. Absolutely a must.

"I belonged to a sorority called DET (Debbie Ephraim Tau) Sorority Girls. Members included Geri Werner Zelson, Isabelle Hicks Ulan, Ruth Flancer Lewis, Jean Pressman, Harriet Lippman, Bubbles Kubanoff Stein, and Miriam Singer.

"Then there [were] the EPU Boys, a fraternity [that], after short meetings on Friday nights, [was] invited over to the various girls' homes for partying. Joe Zelson, Danny Lipschutz, Joe Barag, Joe Lackman, Frank Arnold, Aaron Knopman, Alvin Portin, Bob Simon, Dave "Mitzi" Rosen, Ed Paul, Dave Matter, Stanley Leninsky, Sheldon Ogens, Melvin Monheit, Joe Pollock,

Bill Stein, Joe Wagner, and Marty Wagner. Many of those people I still see after 60 long years.

"I married Norman Bell in 1950. Norman and Hy Soifer opened Bell-Soifer Realty and National Business Brokers office at 60th and Chancellor Streets. In 1952, we bought a home in Overbrook Park, built by the Warner West Company at 72nd and Haverford Avenues [in] West Philadelphia. The area was 90 percent young Jewish couples who survived World War II and immediately started new families. The new row homes sold for $8,990 and the GI Bill of Rights made the purchase of a new home very easy with little money down as a deposit.

"Outstanding amongst the businesses on Haverford Avenue included establishments like Barson's Luncheonette, Famous Delicatessen, Liss Bakery, and Syd Gold's Women's Clothes. The community was a repeat of various other sections of West Philadelphia with Jewish neighbors now sitting on front patios with large grassy lawns on warm summer nights discussing plans for future affairs, and major family life cycle events. Everyone was a participant and we thoroughly enjoyed the fellowship and friendships we made in the neighborhood.

"The West Philadelphia community was home to many talented people: Norman Braiman, former owner of the Philadelphia Eagles football team; Larry Magid, a mainstay of the Electric Factory Concerts; Ron Rubin, [a] second-generation real estate developer; Sidney Kimmel, [the] CEO of Jones Apparel; Judith Seitz Rodin, current president of the University of Pennsylvania, located in West Philadelphia; Stan Tuttleman, a prominent philanthropist; and Dr. Gerald Marks, a well-known cancer specialist at Lankenau Hospital. [These are only] a few individuals who called West Philadelphia home."

Thelma Cohen Bell is fortunate to have experienced so much pleasure in the neighborhoods of West Philadelphia.

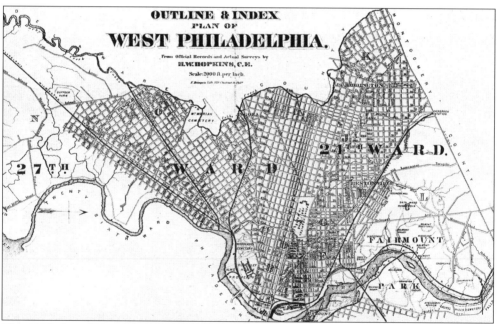

The 1876 plan of West Philadelphia shows a community with many sections branching off its main thoroughfare—Market Street. Symbolically, the configuration of the streets can be viewed as a tree with distinct branches. Jewish life flourished under this tree in West Philadelphia and, like Jewish symbolism in comparison to nature, the crowning of the community defined its full beauty, similar to a tree reaching out to the heavens and displaying all of its foliage. (Courtesy of Larry Magid.)

One
HIDDEN HISTORY

The Jewish community of West Philadelphia is rich in history. Minute details of its past have been recorded in previous writings, but there has been no comprehensive history. The lack of such a volume is a travesty to the history of the Jewish people who assisted in building Philadelphia into a viable city in the 19th and 20th centuries. Thus, the actual documentation of a people that called Philadelphia west of the Schuylkill River home is important to share with the full community for an understanding of how West Philadelphia existed and the growth that took place over several generations as its residents made a life for themselves.

The author began to consider compiling a history of Jewish life in Philadelphia through oral history while a student at Gratz Hebrew College in the 1970s. This photograph was taken at the beginning of that process, where Jefferson Street meets North Fifty-fourth Street at the bottom of the hill in Wynnefield. The image shows the past (the old trolley tracks) being covered to make way for the future. Just a week after the picture was taken, the entire street had been paved over.

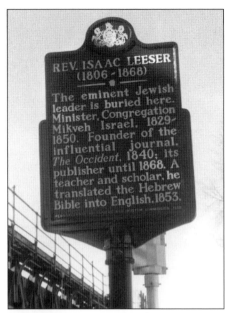

In the 1740s, the first Jewish congregation Mikveh opened its doors. The well-known Gratz family made Philadelphia a crossroads community by blazing a trail west to the outpost, then known as Lancaster, more than 80 miles west of the city in order to trade furs with the Native Americans. The land west of the Schuylkill River was known to these Jewish traders, but it was more than 100 years before West Philadelphia was incorporated into the County of Philadelphia, in 1854. Rev. Isaac Leeser, a former rabbi of Mikveh, Israel, founded his own congregation, Beth El Emeth, near Sixth and Spring Garden Avenues. He also created a cemetery in West Philadelphia, at Fifty-fifth and Market Streets. Cemeteries were located the farthest away from Jewish communities. In the 1890s, Beth El Emeth ceased to exist and was transferred to Mikveh Israel, which now cares for three cemeteries in Philadelphia.

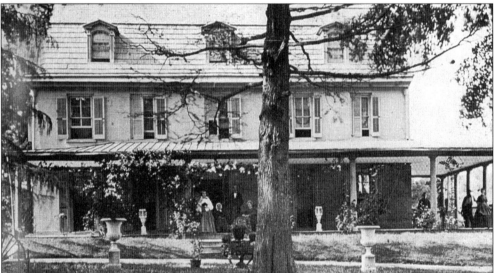

Rabbi Isaac Leeser, visionary leader of the Jewish community in the early to mid-19th century, conceived of several institutions to serve the Jewish residents of Philadelphia vis-à-vis Jewish values of caring for the aged, the orphaned, the widowed, and the sick. Philadelphia, the center of Jewish life in America during the 1850s, argued that a national Jewish hospital should be established in its borders. The concept finally took root more than 15 years later with the assistance of B'nai Brith and partly due to the turmoil of the Civil War. (Jewish veterans were denied access to the military hospitals in the city and were not provided kosher food.) The first Jewish hospital in the city opened in 1865 at Fifty-sixth Street and Haverford Avenue in West Philadelphia, only a mile north of the new Beth-El-Emeth Jewish Cemetery. Eight years later, the hospital relocated to the northern section of the city, where the population shifts made it more feasible to serve a greater number of patients. Jewish Philadelphia history changed overnight. A whole generation passed before Jews reconsidered West Philadelphia as a place of residence in the 1890s. (Courtesy of the Albert Einstein Medical Center.)

B'nai Israel, the fifth synagogue founded in Philadelphia, created a burial ground for its members several years after its founding in 1852. The South Philadelphia congregation worshiped at Fifth and Catherine Streets. In the mid-1850s, B'nai Israel, with the help of community leader Abraham L. Hart, a leading member of the Beth-El-Emeth synagogue, bought land adjacent to Mount Moriah Cemetery. The lot was at Sixty-fifth Street and Kingsessing Avenue, in the western suburbs of Philadelphia. Congregation B'nai Israel disbanded in 1879 (one generation after its founding) and transferred its cemetery to the Hebrew Mutual Benevolent Society, which carried on the tradition of maintenance for the cemetery until it was disbanded in in the late 1960s. Today a new organization—the Preservation of Abandoned Jewish Cemeteries, part of the Board of Rabbis office—seeks public and private funds to restore this cemetery. Interested people can assist this worthwhile project.

Rabbi Chaim Budnick (of blessed memory) pointed out to the author a continuous pattern of 123 Mogen Davids, or Jewish stars, embedded in cement below the roofline on portions of Memorial Hall, designed by Herman Schwarzmann in the 1870s near Fortieth Street and Girard Avenue. The author promised Rabbi Budnick an answer to the question of why the 123 stars are on this building. Could it have something to do with Katie Myrtilla Cohen, a talented artist (her work is part of the Civil War Memorial in Fairmount Park) and sister to Charles J. Cohen, president of the Fairmount Park Commission? This trivia can only be answered by readers.

The large apartment building at the triangle known as the Point, where Fortieth Street and Girard Avenue meet, became the home of the Park Manor, designed by Wiltis Hale and erected in 1897. A restaurant in the basement featured the first Jewish hoagie, known as the knockbockle, a multilayered sandwich with various Jewish cold cuts. The Park Manor ice-cream parlor next door served many people around the neighborhood. (Courtesy of the Robert Skaler collection.)

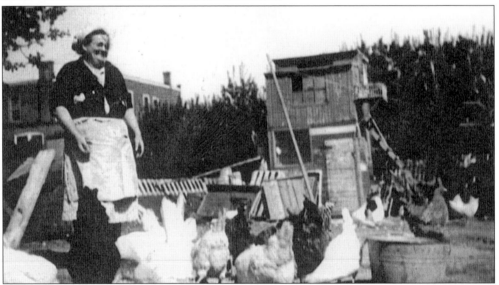

In the 1890s, Jewish settlements sprouted up on farmlands across America, helping to alleviate the congestion in major urban centers from the influx of immigrant Jews from eastern Europe. Philadelphia had a ring of such settlements in each surrounding county and in southern New Jersey. The Hebrew Immigrant Aid Society settled immigrants with agricultural backgrounds in the far southwestern region of Philadelphia known as Eastwick, where Island Road meandered through the low-lying marshes and swamps near the mouth of the Schuylkill and Delaware Rivers. The area was several feet below sea level and, although it often flooded, it provided rich and fertile farmland. Fannie and Louis Bell, content Jewish farmers in Philadelphia, had cows and chickens in the area, fondly referred to as the Meadows. (Courtesy of Ida Scherr.)

A true landmark, the Wynne is recognized throughout Philadelphia. Located in the Wynnefield section, it was named for the attending physician of William Penn. David Wynne lived in this area, a community that dates from the 1690s and one that included a diverse population in the 20th century. The Wynne Theater opened in the 1920s. Later, the Uhr family of South Philadelphia fame renovated the building into the Wynne Caterers. The address on North Fifty-fourth Street was associated with memories of elegant Jewish affairs.

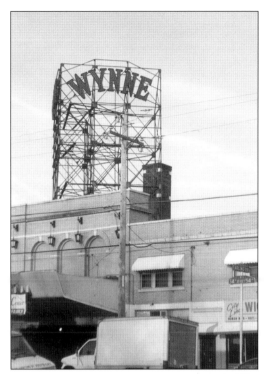

What was originally the Philadelphia Psychiatric Hospital was located at Ford and Monument Avenues (in what later became known as Balwynne Park) and opened in the late 1930s. The science of treating the mentally disabled in the Jewish community became a priority of founder Samuel Radbill from Wynnefield. The facility designed by the well-known architect Israel Demchick allowed dignity and respect to remain at the top of any list to treat the afflicted persons. Today, the institution is part of the Albert Einstein Medical Center group.

The Paschall Jewish congregation, founded in the early 1900s, purchased a historic house on the southeast corner of Sixty-ninth Street and Paschall Avenue. The house was situated only blocks from the well-known Fels Napa soap company and served as a Jewish house of worship for the Woodland Avenue business district near Sixty-third Street. The purchaser, a Mr. Kirschner, maintained the historic house, which was built in the 1770s. A large fireplace added beauty and warmth for the members. The house had an underground escape leading to a field, indicating that the house served as a stop on the Underground Railroad, which brought former black slaves north to freedom during the Civil War.

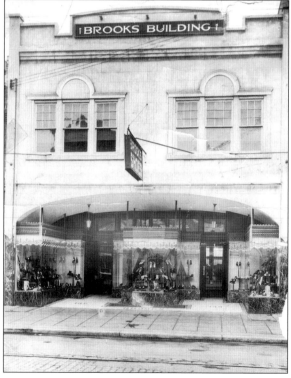

The Sixtieth Street business district served as the largest collection of shops in West Philadelphia. It spanned six long city blocks south of Market Street from c. 1910 until the 1950s. This double store with its elaborate and ornate design typified the era of business window facades and displays in the 1920s. Abe and Rose Brooks swapped their store and location on Sixtieth Street with Wenick's umbrella shop. The Brookses expanded their shoe business and purchased the adjoining property at 137–139 South Sixtieth Street, doubling the amount of their property. (Courtesy of Rudy Brooks.)

Two

BRIDGES ACROSS THE SCHUYLKILL RIVER

Philadelphia, founded in the 17th century, served as a world-class freshwater port. The city ran east-to-west with small harbors along the Delaware River. Exploration and expansion of the city westward took place in the 1700s as the city grew. The Consolidation Act of 1854 incorporated many of the city's nearby suburbs into Philadelphia County; this increased the amount of taxes available to fund city services. Access to what had become West Philadelphia was provided first by individuals who operated ferries across the Schuylkill River. Later, bridges were built with heavy timber (plentiful in Pennsylvania) at key streets, such as Market Street, to transport vehicles used for the construction of new housing in the undeveloped expanses. The safety and integrity of these early bridges were often tested by their builders by driving caravans of heavily laden wagons over them. In the late 1890s, new iron and steel bridges spanned the Schuylkill River, creating new pathways to the neighborhoods of West Philadelphia. A large migration of immigrant Jewish people primarily from South and North Philadelphia made their way westward in the late 19th and early 20th centuries in order to make better lives for themselves and their families.

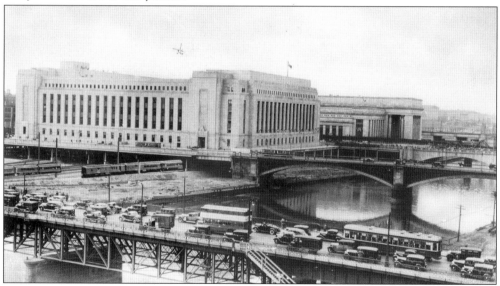

This postcard view depicts a trio of bridges that crossed the Schuylkill River with West Philadelphia's two gigantic landmarks in the background. The Thirtieth Street Railroad Station, the hub stop for all trains coming into the city, and the main U.S. Post Office took up residence early in West Philadelphia's history. The Walnut Street Bridge carried a heavy load of daily traffic only westbound. The Market Street Bridge carried traffic in both directions, along with a separate bridge for the Market Street elevated train until a tunnel was constructed under the riverbed for the elevated train and the trolley cars to speed passengers to downtown destinations. (Courtesy of Walter Spector.)

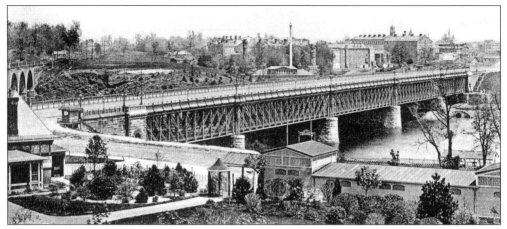

The Consolidation Act of 1854 united all districts and villages into one entity, called Philadelphia County. Eleven bridges were built over the Schuylkill River in the 19th century, making travel around the city convenient. The Girard Avenue bridge dates from 1855. In 1874, Henry and James Sims and the Clark Company built the world's widest bridge, which carried traffic to the U.S. Centennial Exposition grounds at Fortieth Street and Girard Avenue. One generation later, newly arrived Jewish eastern European immigrant families who migrated to Strawberry Mansion traveled to West Philadelphia safely and quickly via the many trolley car routes to visit friends and relatives. A *shtetl* (regional community) soon developed on both sides of the Schuylkill River, each with access to the other via the ever-evolving citywide trolley car system. (Courtesy of Walter Spector.)

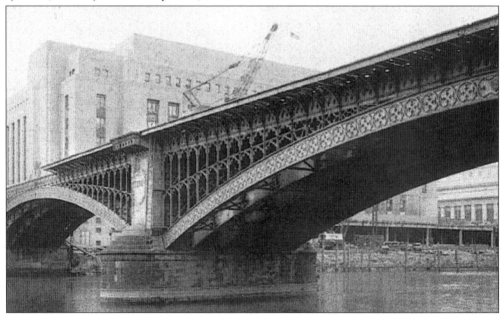

A major connector to West Philadelphia is the Chestnut Street Bridge. The span, located between the Market Street Bridge and Walnut Street Bridge, carried heavy traffic eastbound (out of West Philadelphia) into Center City. Trolley service made up the bulk of traffic. Cars from several lines crossed the bridge hourly from the 1890s until the 1950s. Today, its beautiful form and graceful arches are lighted at night. (Courtesy of Historic and American Engineering Record, Library of Congress.)

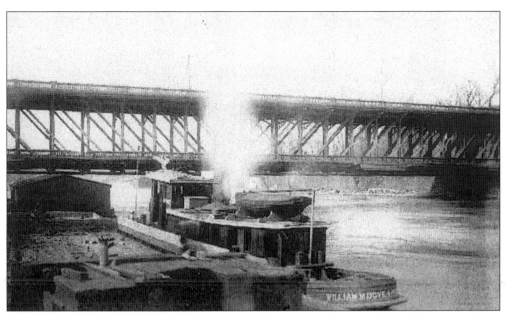

The Spring Garden Street Bridge, built in 1813 by architect Lewis Wernwag, connected North Philadelphia with the Mantua district. The bridge was destroyed by fire in 1840 and replaced with the first wire bridge in 1842, designed by architect Charles Ellet. The new double-deck bridge made travel across the Schuylkill River safe and fast for centennial celebrations held on the west bank of the river. (Courtesy of Historic and American Engineering Record, Library of Congress.)

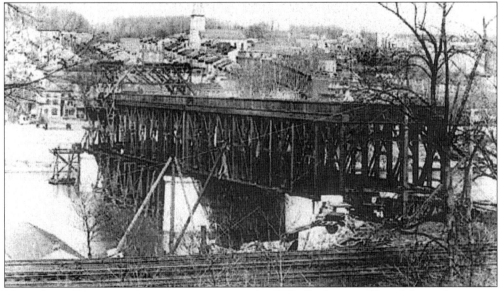

More than 100 years after its construction, the Falls Bridge is still widely used to carry automobile traffic to Wynnefield Heights. In the 1890s, the Falls Bridge was constructed with a large quantity of steel rivets and plate steel; it became the safest bridge in the city. Originally, a top deck was planned to carry a trolley car line across the Schuylkill River. The ornate, cast-iron protective railing, highlighted in light-green paint, blends with the natural scenery. (Courtesy of Historic and American Engineering Record, Library of Congress.)

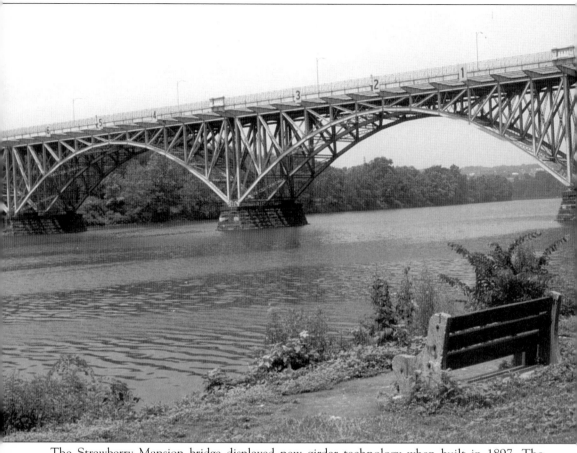

The Strawberry Mansion bridge displayed new girder technology when built in 1897. The centennial celebrations of the 1870s spurred development of communities on both banks of the Schuylkill River. Strawberry Mansion, a Jewish neighborhood dating to the same era, could be reached at the end of the Park Trolley Car Line in Parkside after a scenic ride through Fairmount Park, with stops at Woodside Park and Crystal Pool in the summertime. Jewish families often took rides on the trolley cars to visit relatives in both communities. During July and August, people enjoyed an evening out by taking a round-trip ride via the open-air trolley, which crossed the Strawberry Mansion bridge.

Three

TWO FARES FOR FIFTEEN CENTS

The development of the western section of Philadelphia took place after the communities there were linked with downtown via many bridges. The next development came in the 19th century with the creation of a public transportation system, initially organized by private investment. Horse-drawn trolleys filled the streets of West Philadelphia after the Civil War. The extension of the city into West Philadelphia only went as far as Forty-sixth and Market Streets in the 1890s. Two monumental developments took place in the 1890s and early 1900s. The electrification of the trolley cars and the creation of an elevated railroad similar to New York City's famed system became reality. Frantic building of homes and businesses took place within a 20-year period before the outbreak of World War I. Richard Short, a native of South Ardmore, migrated to Philadelphia with his parents. Born in 1932, Richard grew up with trolley cars all his adult life and also enjoyed trains so much that he became a towerman, directing trains for the Reading Railroad after World War II. The thrill of riding and photographing trains and trolley cars turned into a lifelong avocation. His collection is a legacy to his untiring desire to document the Philadelphia transportation system through photographs.

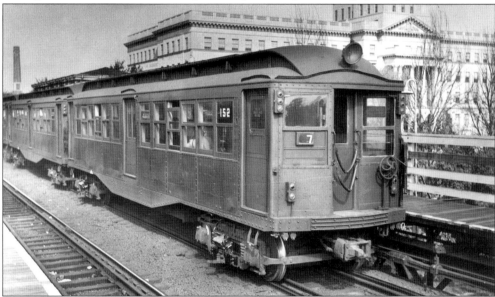

The backbone of the West Philadelphia public transportation system was the Market Street El from downtown Philadelphia to its terminus at Sixty-ninth and Market Streets. The familiar brown elevated trains built by the Standard Pressed Steel Company went into service in 1908. West Philadelphia expanded rapidly past Forty-sixth Street (above, with the Provident Mutual Insurance building in the background). Children of all ages enjoyed the view from the front car of the train as it raced through West Philadelphia, similar to a roller coaster ride. (Courtesy of the Richard Short collection.)

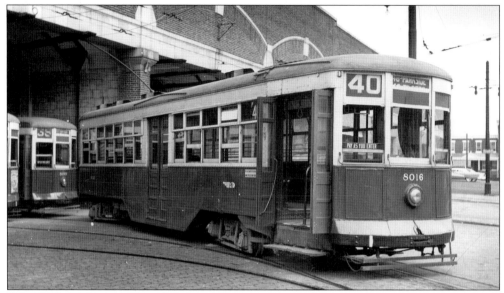

West Philadelphia can be called the trolley car capital of the world. The vast community of West Philadelphia seemed to shrink as a result of the excellent transportation system. More than 30 trolley car lines traveled up and down, across, and over many sections of the area west of the Schuylkill River. The No. 40 trolley car retired to the Fifty-ninth and Callowhill Street car barn for the night after bringing riders from the downtown area to Fortieth Street and Girard Avenue. (Courtesy of the Richard Short collection.)

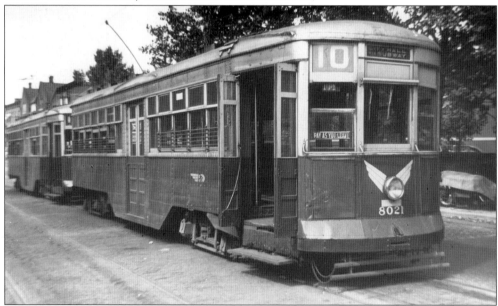

The northwest section of West Philadelphia above Market Street served several trolley car routes by using the same tracks (the right-of-way system), good news for the riding public waiting for the No. 10 trolley car on Lancaster Avenue. The merchants could hear the clang of the trolley car bell every hour as the conductor alerted drivers of double-parked cars waiting for their passenger to come out of Wolffe's bicycle shop, Weinstein's building supplies, or the Overbrook Pharmacy on Lansdowne Avenue at Sixtieth Street. (Courtesy of the Richard Short collection.)

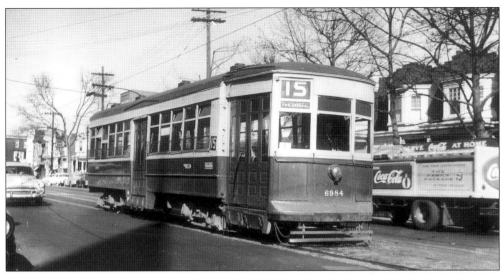

The popularity of the trolley car is a Philadelphia tradition, and the newly arrived Jewish immigrants quickly fell in love with them. Many streetcars connected West Philadelphia with other parts of the city. Route No. 15 ran along Girard Avenue for many miles and gave West Philadelphians access to Broad Street and Girard Avenue—home of the well-known Majestic Hotel, which catered to large Jewish wedding receptions. Only a few blocks farther east stood the famous Marshall Street shopping district, where 100 Jewish merchants ran an open-air farmers' market, complete with pushcarts.

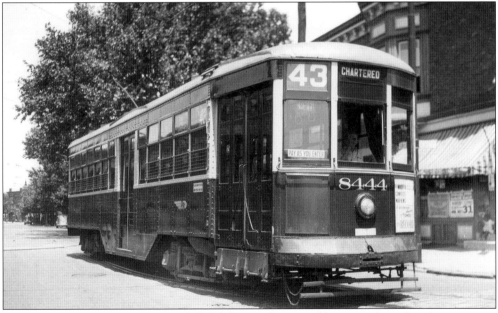

The layout of the streets in West Philadelphia made it possible to use the right-of-way system. Spring Garden Avenue intersected with Lancaster Avenue to allow the No. 43 trolley car to travel on its way to Fifty-second Street and Parkside Avenue. The phrase "trolleys are a dime a dozen" referred to 12 trolley cars passing by the same trolley stop within an hour for a 10¢ ride to downtown. That amounted to one trolley car every five minutes. (Courtesy of the Richard Short collection.)

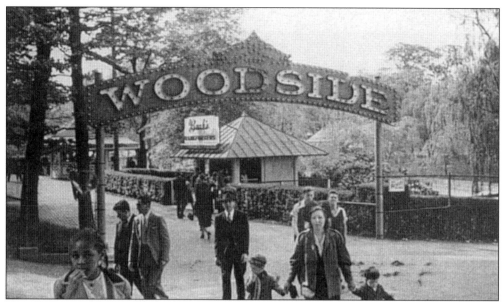

Woodside Park, Philadelphia's most beloved amusement park, existed from the 1890s until the late 1940s, serving several generations of children and adults. Located in Fairmount Park on the western banks of the Schuylkill River, this piece of Americana was shared by all ethnic groups during the summer months. The rides included the famous Hummer roller coaster, the Whip, and the Wild Cat. The mechanical talking clown Charlie greeted children and their parents, teenagers with their sweethearts, and older couples—all of whom came to enjoy a great day outdoors during the warm summer months. (Courtesy of Lillian Ring.)

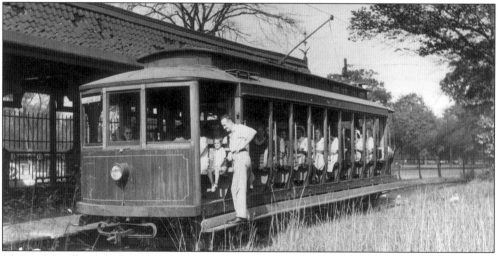

The Park Trolley operated in a circular route going through the most scenic parts of Fairmount Park in West Philadelphia and Strawberry Mansion on the east side of the Schuylkill River. The 10-mile route featured summertime open-air trolleys to transfer thousands of fun seekers to famous Philadelphia venues such as Woodside Amusement Park, Crystal Pool, and the Robin Hood Dell, an open-air amphitheater. Many delightful memories are recalled of faces smeared with chocolate ice cream dispensed from Pflaumer's ice-cream parlor while sitting on their famous European-style patio cafe on Thirty-third Street and Ridge Avenue, across from the Park Trolley and the Robin Hood Dell. (Courtesy of the Richard Short collection.)

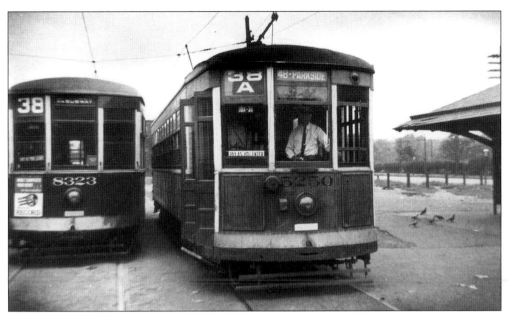

Several trolley cars ended their routes at the large terminal at Forty-fourth (Belmont) and Parkside. The centennial exhibition grounds across the street made this an ideal location for a trolley car depot. Years later, the No. 38 trolley car came up Fortieth Street after its run from the downtown district. The 38A terminated at Fifty-second and Jefferson Streets in the Parkside section in the late 1920s when new houses were built. (Courtesy of Richard Short collection.)

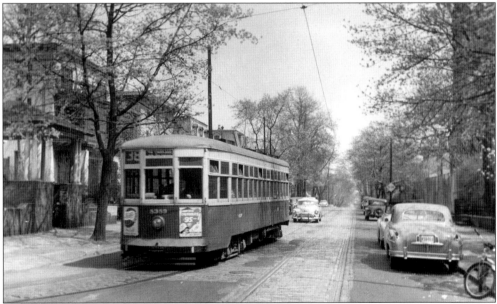

West Philadelphia, known for its front lawns and tree-lined streets, portrayed a suburban look. Trolley cars running up and down its street were attractive to residents as safe and convenient transportation from right outside one's doorstep. This photograph, taken on Baring Avenue in Mantua, includes a bicycle in the lower right that belonged to Richard Short, who often rode around several neighborhoods a day photographing different trolley lines in the 1950s. (Courtesy of the Richard Short collection.)

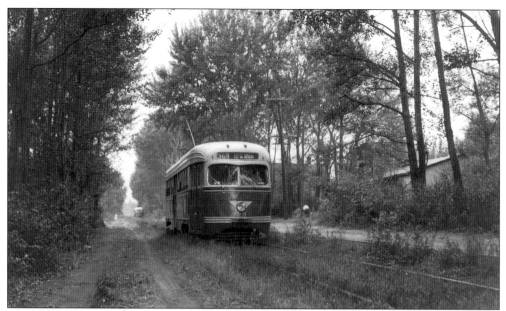

Certain sections of West Philadelphia expanded into suburban districts, especially on its western edge. During the late 1890s, after the completion of the new city hall at Fifteenth and Market Streets, construction of row and twin houses in the Eastwick section of Southwest Philadelphia made it profitable to run and maintain the No. 36 trolley car on Island Road. This line connected the Eastwick area via Elmwood Avenue with downtown. A new depot facility at Elmwood and Island Avenues sheltered the growing fleet of trolley cars serving this area. (Courtesy of the Richard Short collection.)

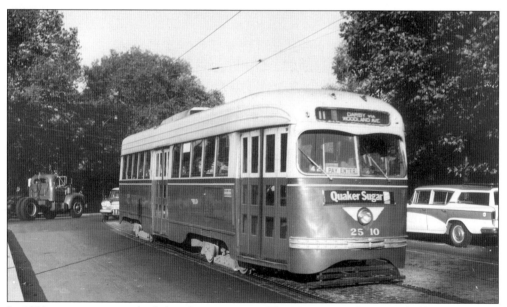

In 1901, a new city-to-suburb line began service. The No. 11 ran from city hall to Southwest Philadelphia via Woodland Avenue on its way to Darby. Access to Delaware County along Mac Dade Boulevard included Mount Lebanon, a Jewish cemetery and Har Yehuda Cemetery in Lansdowne. (Courtesy of the Richard Short collection.)

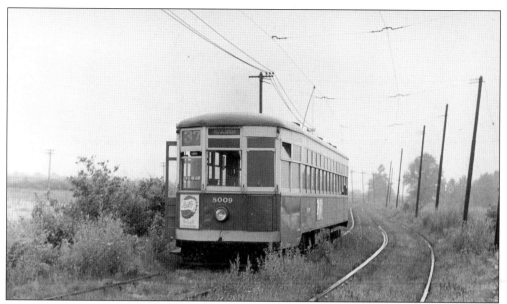

Suburban towns dot the landscape every 20 miles from the borders of the city. The southwest corridor along the Delaware River past Eastwick included Essington and Chester. The original Chester & Philadelphia Railroad Company connected two cities via a high-speed, inter-urban line that dated to 1900, which later became the No. 37. Jewish families could send packages along with the conductor from one point to another or visit relatives in West Philadelphia. (Courtesy of the Richard Short collection.)

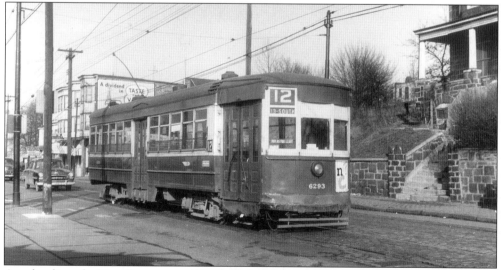

Another line, the No. 12, connected South Philadelphia to West Philadelphia via South Street and ran all the way out to Darby along Woodland Avenue. The attraction for many people to use this line developed as families created better lifestyles for themselves and moved out of, but still wanted to visit relatives in, the old neighborhoods. The ride over the Schuylkill River via Grays Ferry Avenue was a thrill all by itself. Even the homes in Darby, built in 1920s, looked like ones in Southwest Philadelphia. (If you happened to take a snooze on the train you could have woken up only to find yourself out of the city and in the suburbs.) (Courtesy of the Richard Short collection.)

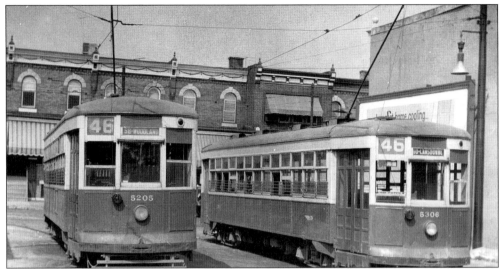

The Brill Company, located at Fifty-eighth and Woodland, produced hundreds of wood-paneled trolley cars during World War I. The No. 46 trolley car, a double-end car, originally terminated right on Fifty-eighth Street, short of Woodland, on a single track. The conductor then had to switch the pole in the opposite direction for the trolley car to go on its way via Sixtieth Street to the upper reaches of West Philadelphia to Sixty-third Street and Malvern Avenue. In the 1920s, an empty lot off Fifty-eighth Street became a Philadelphia trolley landmark—a loop where passengers could wait in safety to connect from the Woodland Avenue trolley car lines. (Courtesy of the Richard Short collection.)

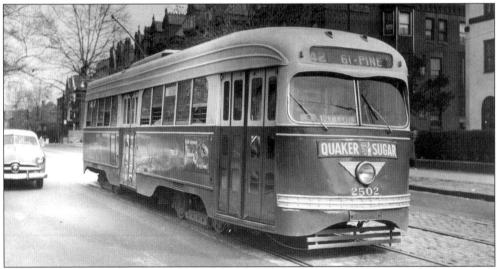

Trolley cars in modern urban centers such as Philadelphia were people movers. The system could move thousands of people from one point to another efficiently and quickly in all types of weather. The well-respected No. 42 trolley car transported thousands of students in West Philadelphia to and from West Philadelphia High School, located right along its route. The No. 42 traveled along the main east-west arteries of Chestnut and Walnut Streets from the West End (the Sixtieth Street corridor) to downtown. The city is well known for its streets, running for blocks and miles through different neighborhoods. It always seemed impossible to get lost. (Courtesy of the Richard Short collection.)

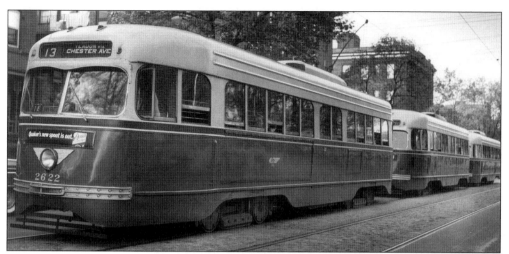

Caravans of trolley cars (three or more) were a common sight on the streets of West Philadelphia during World War II, transporting many people to their jobs. In the early 1940s, the St. Louis Car Company built a new prototype trolley car that ran smoother and faster. These streamlined trolley cars were first used on the No. 13 route on Chester Avenue. They were designed by C.F. Hirshfeld, a Jewish engineer. A Mr. Conway of the same company added a safety feature: windows that opened only at the top to prevent the possibility of it slamming down on someone's arm resting on the window sill. The experiment did not work and the windows remained with the opening at the bottom. Instead, three shiny bars were spaced four inches apart at the bottom of each window to prevent injury to the public. (Courtesy of the Richard Short collection.)

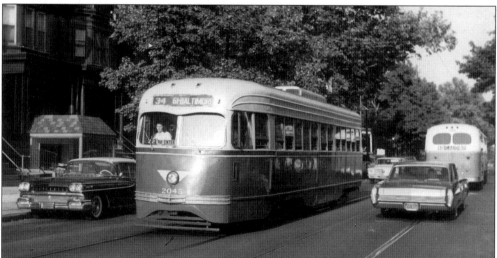

Another spider vein road running through West Philadelphia includes the famed Baltimore Pike, which led southward out of the city heading to Baltimore, Maryland. The new trolley cars on the No. 34 route touted a new lighting system (fisheye light lens) so that riders could read the newspaper after dusk. Congestion through the University of Pennsylvania and Drexel College campuses near Thirty-fourth and Market Streets was alleviated with the construction of the two separate trolley portals (tunnels), which sped people downtown and to the city hall area. Automobile drivers who attempted to use the portals soon found themselves stuck on the railroad ties and in need of a tow truck. (Courtesy of the Richard Short collection.)

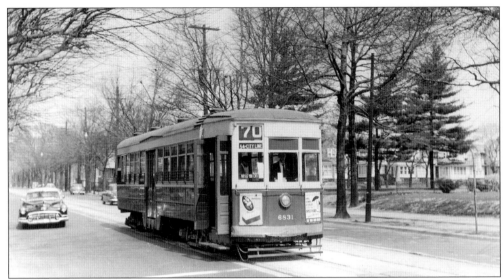

Sections of western Philadelphia included the upscale and exclusive neighborhood known as Wynnefield, located north of the Parkside section. In the 1920s, access to Wynnefield—according to the author's mother, the former Esther Ponnock (of blessed memory), daughter of Rose and Louis Ponnock—was by chauffeur-driven automobiles. Notable residents (such as Abe and Rose Ponnock of Ponnock Toys at Fifth and Market Streets) often rode the No. 70 trolley car down Fifty-fourth Street and connected to the Market Street El at Fifty-second Street to see a film at the Nixon or State movie houses, before the Wynne Theater was built in their neighborhood during the 1920s. (Courtesy of the Richard Short collection.)

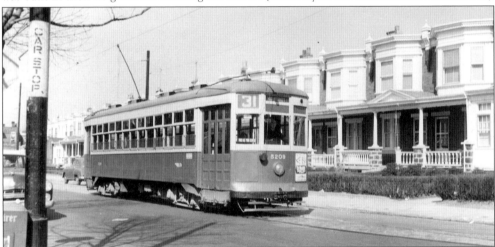

Far northwest reaches of West Philadelphia were made accessible via the No. 31 trolley car line, which ran from downtown out to Sixty-third and Market Streets, on its way to Seventieth Street and Lansdowne Avenue. Some people refused to climb the steps to the Market Street El and thus relied on an easier mode of transportation. After World War II, Jewish people who migrated from the Sixtieth Street corridor took the No. 31 to their new neighborhood, Overbook Park, and then walked up the hill from Lansdowne and Haverford trolley. In the mid-1950s, the No. 31 bus line replaced the trolley line and went up Haverford Avenue to City Line Avenue to service the riding public who bought new homes built by the Warner West Company. (Courtesy of the Richard Short collection.)

Four

OUR NEIGHBORHOODS, OUR FAMILIES

The Jewish neighborhoods throughout West Philadelphia, Fortieth and Girard, Parkside, Wynnefield, Overbrook Park, Southwest Philadelphia, and the Island Road communities were made up of families that came to the area as transplanted units from South Philadelphia. This first upscale migration and relocation (during the 1890s) included a small segment of the German Jewish population, which resettled west of the Schuylkill River in a bold move to extend their living arrangements apart from North Philadelphia. A contingent of immigrants bypassed South Philadelphia and Strawberry Mansion to live in this second settlement area with its wider streets, larger homes, and grass lawns. The primary neighborhoods that supported Jewish life with synagogues, kosher butchers, Jewish bakeries, grocery stores, and delicatessens reminded the many Jewish residents—whether renters, homeowners, or apartment dwellers—of the old-world order from which they escaped due to religious persecution. The non-Jewish population recognized where the Jewish neighborhoods were located and most often avoided them.

The architecture of the row homes in West Philadelphia, especially in the Fortieth and Girard section, represented the quaintness of the Victorian era. The birthplace of Phil Weiner (3836 Brown Street) had many amenities that represented the common housing stock of the community. Some homes were twins; others were connected row homes, two or three stories high. Most were outfitted with decorative wooden front porches similar to those in the country. The homes included rounded bay windows and tin craftsmanship; they were extensive in detail and were usually topped off with an impressive steeple. The wrought-iron fences added another Victorian touch. The modern era interrupts this quiet scene with a car garage built between the houses. Even the once wooden steps were converted to the cement bull-nosed style, great for playing step ball. (Courtesy of Phil Weiner.)

 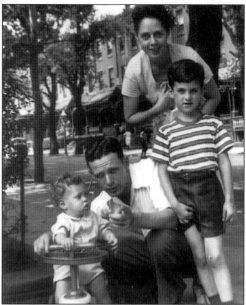

Left: Brothers Bobby and Joel Spivak, sons of Phil and Helen, are in front of their house at 4133 Cambridge Street *c.* 1939. The boys played in Fairmount Park. Bobby is now the head of Sports USA for Israel and involved with the Maccabi Games, athletic games held annually across America. Joel is an architect. (Courtesy of Joel Spivak.) *Right:* Herman and Sara Swidler Krantweiss lived in a third-floor apartment at 1132 North Forty-first Street in the late 1940s. There they raised their sons, Jerry and Robert. In 1952, the family migrated to 550 South Fifty-ninth Street, another Jewish neighborhood. (Courtesy of Bob Krantweiss.)

Employing a live pony was a famous tactic used by men who made a living taking photographs of children in various immigrant neighborhoods. This gave way to kid-sized pedal cars in the late 1930s. Maury Dicther sat still for this photograph at 4112 Girard Avenue. The Cohens were lucky enough to have Drs. Bleecher, Sloan, Glazer, Segal, and Kessler nearby. The neighborhood was full of culture. Esther's friend Toma Simon's father ran the Girard Avenue Workman Circle School. Girard Avenue had many great aromas emanating from Felton's Bakery next to the Grant Movies and the Park Manor apartment building. (Courtesy of Esther Cohen Dichter.)

Left: The author's paternal grandparents, Alexander and Elsie Meyerowitz, and their family migrated back to the city from the farmlands of Quakertown and resided at 4227 Wyalusing Avenue. The family survived the Great Depression by setting up an egg route that served the general community. *Right:* Yetta Biederman and her friend Zluta Katz posed in Fairmount Park near Echo Hall, the Civil War monument. Yetta and her husband, Harry, operated a kosher meat market at 871 North Fortieth Street. Later, the couple became one of the first dressed-poultry dealers in Philadelphia. They sold the market to their relatives Louis and Minnie Skaler. (Courtesy of the Robert Skaler collection.)

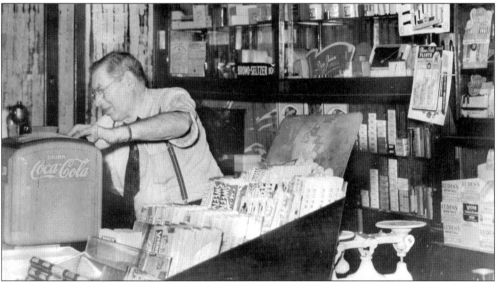

Proud business owners such as Benjamin Smiler, originally from South Philadelphia, migrated to Fortieth and Parrish Streets along with his wife, Esther, to open his pharmacy in 1913. The Smilers' drugstore sold many popular patent medicines and had a Coca-Cola soda fountain. The couple raised a family above the store (as was the norm in West Philadelphia) until 1948, when the Smilers moved to Wynnefield. (Courtesy of Irv Smiler.)

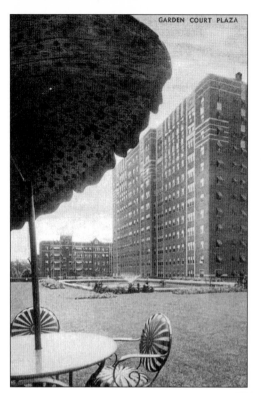

The Garden Court District, Philadelphia's first modern automobile suburb, was developed by Clarence Siegel immediately after World War I and nurtured a new era in housing stocks and layouts in the area, which was bounded by Pine Street, down to Larchwood Avenue, and westward from Forty-sixth to Fiftieth Streets. The area was crowned with the Garden Court Plaza (designed by the famous architect Ralph B. Bencker) and featured several stories of garaged parking space for automobiles. The concept to build communities with garages and rear driveways became a very progressive concept in Philadelphia. Nearby, at 4900 Samson Street, in the 1920s, Benjamin Herman built typical row houses with buff-color bricks, enclosed sun porches, garages, and driveways. He later moved his family into one of the homes he built. (Courtesy of the Robert Skaler collection.)

The Walnut Park Plaza, a premier hotel and apartment building, stood at the edge of West Philadelphia on Cobb's Creek Parkway and Sixty-third Street. The facility contained elegant banquet rooms for affairs, such as those for the West Philadelphia Jewish Community Center Synagogue, only a block away. The author's grandfather Alexander Meyerowitz belonged to the carpenter's union and helped to erect this magnificent building. (Courtesy of the Robert Skaler collection.)

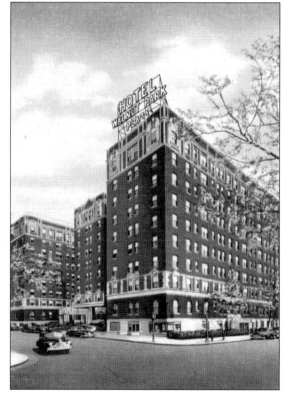

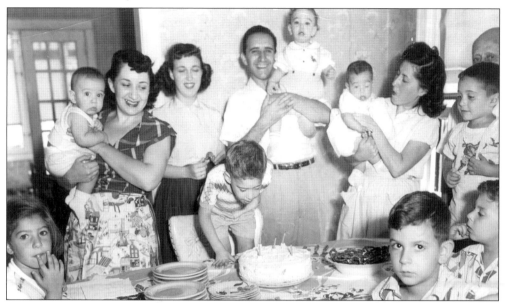

Jewish life during the 1950s revolved around family and life cycle events. Business owners who rarely took a day off, except for closing early on Tuesday nights (the slowest night), treasured those special family moments. Lots of people came to Phil and Estelle's apartment above their luncheonette in Southwest Philadelphia to celebrate their son Marc's fourth birthday party in 1951. Sol and Louise Cooperstein, who owned Penn Electric at Sixtieth and Markets Streets, brought their son Bobby to the party and joined Elsie, Debbie, and Harry Cooperstein for cake and ice cream. (Courtesy of Estelle Cooperstein Greenstein.)

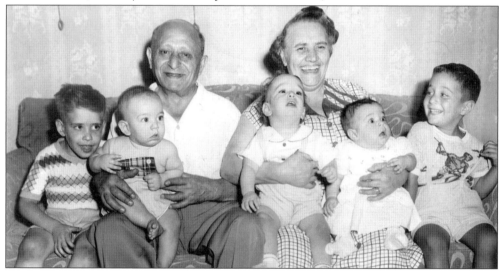

The greatest thrill for Jewish people is to became a Zada or a Bubbie. The *naches* alleviates the aches and pains of growing old that one gets from schlepping grandchildren around. Lena and Harry Cooperstein catered to the kids on the sofa with much enthusiasm in their hearts. The grandchildren shown here are, from left to right, Marc and Dennis Greenstein and their cousins Bobby, Debbie, and Ricki Cooperstein. This happy episode took place above Phil's Luncheonette at 5661 Beaumount Avenue, where cotton slipcovers were a must. (Courtesy of Estelle Cooperstein Greenstein and Sandy Seigel.)

East European immigrants landed in Philadelphia in the 1880s and 1890s, after passing through a quarantine island near Essington. Jewish people found their way to the southernmost tip of West Philadelphia in a community called Island Road, where much of the land sunk below sea level by a few feet. The small Jewish community of 1,000 people included the Benjamin Lasensky family, including wife Ida and children Marge, Joe, Hassie, and Shirley. The family lived at 3016 South Eighty-fourth Street from 1921 until 1949. Benjamin founded the small lending institution called the Corporation, which made small loans repayable in installments. A trolley car connected South Philadelphia with Island Road. Benjamin Lasensky started the Kiddies Club to raise money for the Jewish orphanage at Ninth and Shunk Streets. (Courtesy Shirley Polansky.)

Family gatherings defined the Island Road Jewish community, which supported several kosher butcher shops and two synagogues, one at Eightieth and Harley (Agudas Achim) and one at Eighty-fourth and Harley (Atereth Israel). The community often congregated in each other's huge backyards to socialize. Paul Cohen, a kosher butcher who had his store at 7736 Brewster Avenue, invited friends over to the Yaskins' on Harley Street for a picnic. The whole crowd showed up, including Rose Yaskin, Ida Sher, Si Finklestein, Jack Schwartz, Sid and Irv Cohen, the Goodsakens, Phil Levicoff, Abe Yaskin the plumber, Morris the grocer, and Harry Freedman. (Courtesy of Sid Cohen.)

 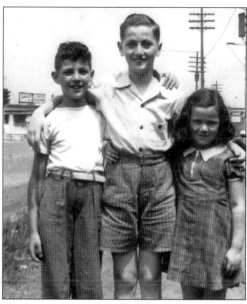

Left: This rare photograph of the area known as the Meadows, where the Jewish community of Island Road in Southwest Philadelphia was located, depicts the true nature of the landscape that reminded everyone of a romantic and faraway land. Elsie Gordon, Jacob Friedman, and Elsie Friedman enjoy a typical day in 1916, spread out in the tall grasses that gave the area its nickname. (Courtesy of Heshie Friedman.) *Right:* Children found many things to entertain themselves in the Island Road Jewish community. The Ehrlich children, Ted, Jackie, and Meyer from Tinicum Avenue, loved their small town center at Eighty-fourth and Eastwick, which included the Cresson Movies, Embinder candy store, Freedman's Deli, and Wolfie's Luncheonette. The children loved to go fishing in the summertime at the Bow Creek, where the No. 36 trolley car terminated. (Courtesy of Meyer Ehrlich.)

Island Road had a rural flavor. The Hebrew Immigrant Aid Society settled Jews who wanted to farm the land here as early as the 1890s. Ditches with running streams of water were common to the community, all of which was originally swampland. Ida Scherr, husband Dave (Tuby), and daughters Lenora and Sandy (pictured) loved the area. (Courtesy of Jackie Ehrlich Hanover.)

Mike Kaplan, son of Sixtieth Street shoe merchants Hymie and Rebecca Kaplan, often played behind the store as a child. Life on Sixtieth Street was filled with excitement and adventure everyday. Dodging the trolley cars on the way to the Bryant School, getting penny candy at Moe's candy store, or playing pinball at Benny's Pool Room could fill entire days. Children peered through the cracked glass block windows of the Sixtieth and Pine Street *Schvitz* (bathhouse) to see the older men socializing. (Courtesy of Mike Kaplan.)

Brothers Barry and Allen Sirkin and Joan (of blessed memory) grew up at Fifty-ninth and Locust Streets. Their parents, Sidney and Esther, enjoyed the music produced by Len (Borisoff) Barry. The children had a great childhood, which included playing in the famous brickyard located at Fifty-seventh and Spruce Streets, until Sayre Junior High School was built in the late 1940s. Boyhood friends included Zack Stalberg (of the *Daily News*), Arnie Golstein, Rabbi Jerry Berkowitz, Chuck Esrid, Jerry Wattenmaker, Sylvan Cohen, Oscar Goodman (now the mayor of Las Vegas), and Stanley Needleman. Allen now heads the Van Huesen shirt company. (Courtesy of Barry Sirkin.)

The community below Sixtieth Street and Larchwood Avenue was known as Cobbs Creek. It extended to Baltimore Avenue along Cobbs Creek, where the famous tennis courts existed, and cut into the park known as the Hollow. A well-known and respected insurance man for Metropolitan Life, Max Freed and his wife, Esther, lived at 6125 Catherine Street. Max was a founder of the Agudas Achim synagogue at Fifth and Main Streets in Darby before moving three miles to West Philadelphia. (Courtesy of Sylvia Freed Guralnik.)

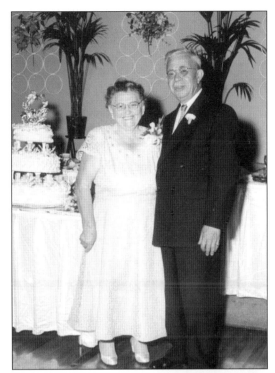

Politicians and the Sixtieth Street shopping district went hand in hand. Both the Republican and Democratic committee people had their meeting halls in West Philadelphia's busiest shopping district. Rose and David Labov were involved with various businesses in West Philadelphia until they finally settled at 6042 Pine Street. As a new Republican committeeman in the 1930s, David became friends with Sam Dunbar, a strong ward leader who always got the vote out for each election by knocking on everyone's door. (Courtesy of Flora Labov Karasin.)

The Wynnefield section, in the western part of Philadelphia north of the Parkside neighborhood, was known for its large homes. It developed as a Jewish suburb within the city limits after World War I. The real estate people who knew the area best included Benjamin and Mary Cobrin, who lived at 5448 Lebanon Avenue and had their business for many years on North Fifty-fourth Street. There are many mysteries about the neighborhoods in West Philadelphia. One is "Why didn't Wynnefield have a Fifty-fifth Street?" (Courtesy of Len Cobrin.)

The community of Wynnefield had definite classifications of housing, which defined the multi-socioeconomic classes, similar to its neighboring community of Strawberry Mansion directly across the Schuylkill River. The working class lived at the bottom of Wynnefield in older row homes with open front porches on Columbia Avenue. The middle class lived in modern, light brick homes with enclosed sun porches. The upper-middle class lived in twin homes built before and after World War II starting on Gainor Road and continuing to Wynnefield Avenue. The wealthiest class lived in stone mansions above Overbrook Avenue. Alvin Applebaum grew up in Wynnefield with his parents, Bernard and Rose who, like many other Jewish residents, were proud of their American heritage and displayed the American flag four times a year: Memorial Day, Flag Day, the Fourth of July, and Labor Day. (Courtesy of Alvin Applebaum.)

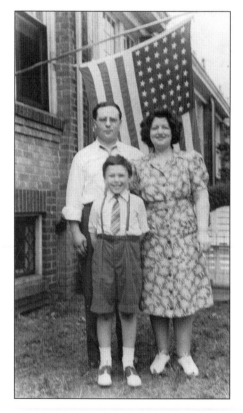

Another great Wynnefield street to live on was Georges Lane. Every corner in the community had a kosher butcher shop, bringing the total to more than 40 in the community at its peak in the 1950s. Morris and Clara Goldberg lived at 1715 Georges Lane and enjoyed raising a family. (Note the metal rocking chairs vented with a basket-weave design for comfort and ventilation on hot summer nights.) The Fishman boys, Mennie and Nummie, delivered ice from a horse-drawn wagon during the 1940s. Other residents included Buddy Mickey Danno, Wilbur and Stan Greenberg, Dan Goldman, Fred Rosenstein, Harry "Hook" Glassman, Reds Segal, Lenny Gross, Bernie Evans, and Albert Kligman. (Courtesy of Alvin Goldberg.)

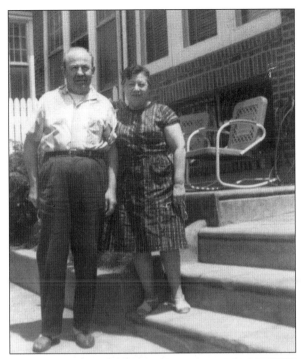

Philadelphia's housing history is very interesting, but very little has been written about it. Light, buff-colored, brick twin homes all set in a row (many with a stained-glass sunburst above their enclosed sun porches) identified popular Jewish neighborhoods in the 1920s. One could find the same housing stock in Feltonville, South Philadelphia, Oak Lane, West Oak Lane, Strawberry Mansion, Southwest Philadelphia, Oxford Circle, and Wynnfield. The common driveways were home to children who played countless hours of box ball, wire ball, or wall ball. Corner properties were usually reserved for businesses and, in Wynnfield, the Potash candy store, at Fifty-third and Euclid (pictured), sold penny candy, dispensed ice cream, and had a soda fountain with single swivel seats at its counter. The school-aged children played a street game called chink, or hand racketball, against the walls of their favorite candy store for many hours at a time. Other candy stores in Wynnfield included Budnick's, Wachtel's, Greenberg's, Blum's, Ott's, Scottie's, and Mintz.

The Overbrook Park section of Philadelphia, in the upper reaches of the northwestern quadrant beyond West Philadelphia proper, had vast stretches of open and undeveloped land into the late 1940s. The returning GIs from World War II, many of whom married their childhood sweethearts, found scarce amounts of housing suitable for married life. Many young married couples doubled up with parents or split apartments with siblings in West Philadelphia. Eugene and Esther Dichter, who grew up at Fortieth and Girard, were no exceptions. Finally in 1952, they purchased their starter house at 7636 Wyndale Avenue, built by Bodek builders. The thrill of seeing your new home in various construction phases is a memory that lasts a lifetime, like the smell of your home's brand-new wood. The Dichter's thoroughly enjoyed their young married years, raising a family, going to the new synagogue on Woodbine Avenue, and shopping at brand-new shops with old familiar names such as Barson's Luncheonette on Haverford Avenue. (Courtesy of Eugene and Esther Dichter.)

Visiting family is always a pleasant experience, and many siblings were happy for each other as the general Jewish population reached middle-class status in the 1950s, one generation after arriving in Philadelphia. Estelle and Phil Greenstein of Southwest Philadelphia took Sunday trips out to Overbrook Park with their children to visit Phil's brother-in-law Jack Cooperstein, who had purchased a home on 1309 Pennington Street. The new neighborhood featured huge lawns. The stock floor plan and traditional facade represented the Colonial motif with a touch of American architectural style and the use of triangular accruements used above doorways and atop the rooflines. The influence of Native Americans and their use of the triangle in construction of tepee tents carried over to building styles in America throughout the 20th century. Jack, a photographer and a returning GI, served in U.S. Navy as a Vee Mail specialist, taking messages off reels of film sent to foreign localities and printing them. A good friend, Bernie Mozer of West Philadelphia, influenced Jack to become a professional photographer. (Courtesy of Estelle Cooperstein Greenstein.)

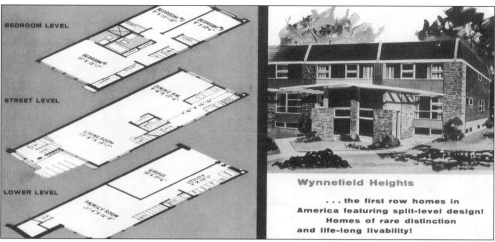

BEDROOM LEVEL

STREET LEVEL

LOWER LEVEL

Wynnefield Heights

... the first row homes in America featuring split-level design! Homes of rare distinction and life-long livability!

The third urban suburb, Wynnefield Heights, was built within the city limits of Philadelphia on the former site of the Philadelphia Polo and Cricket Country Club in the late 1950s. The row homes built by the National Construction Company portrayed similar American architectural facades, but that is where the similarities ended. The costly homes, with hefty price tags of $15,990, offered modern suburban amenities of a finished basement and featured wall-mounted appliances, a split-level floor plan (easy for access to the main living and sleeping quarters). They filled streets such Mimi Court, Lankenau, and Country Club Roads. Another development, Balwynne Park, built on the grounds of the former Woodside Amusement Park, incorporated multifamily dwellings (duplexes) for beginning families who shared them with relatives or bought them as investment properties. Max's Deli was a favorite place to meet on Ford Road. Later, the Downtown Home for the Aged relocated here. (Courtesy of Bob Weiss.)

The modern suburban look of a development in Wynnefield Heights, off Conshohocken Avenue, was achieved by razing all of the trees and growth, thus giving the builder complete control of building grades. Carole and Richard Lichtman from Southwest Philadelphia moved in to their newly built home at 3754 Lankenau Road in 1959. Their son Scott remembers taking a yellow school bus to the Mann Elementary School in Wynnefield and seeing the hucksters hawk their products with a loudspeaker in the rear driveways. The seltzer man, who delivered heavy glass bottles with a spritzer to dispense the bubbling soda water, came back for returns and to replenish the stock. On Sunday mornings, the Medoff bagel truck offered bags of hot bagels to all the Jewish moms, typically all of whom had aprons on and young children at their side. A large, triangular piece of ground served as common garden. (Courtesy of Scott Lichtman.)

Apartment Row, on Conshohocken Road, was the result of several factors during the 1950s and 1960s. The economic status of the Jewish population in the city improved; most attained middle-class status by 1955. Work days were cut to five with weekends off for religious and recreation opportunities. Jews moved out of older first- and second-settlement areas to improve their quality of life. Some Jewish couples now faced the prospect of being an "empty nester," with a big house to clean. The huge Presidential apartment complex went up in 1959 off City Line Avenue at the entrance to the Schuylkill Expressway. Developer Edwin Ducat from Har Zion Temple built the Duffield House at 3701 Conshohocken Avenue in 1963. Other apartment buildings made this area the premier address for independent living in the region.

The Brith Sholom House at 3939 Conshohocken Road, in the Wynnefield Height section off the West River Drive, represented a new era in retirement and independent living. The social and beneficial organization known as Brith Sholom ran camps outside of Philadelphia in Collegeville (Brith Sholomville) and wanted to serve the same clients in various stages of their lives. As Jewish neighborhoods collapsed as viable retirement areas, the need for older residents to find safe shelter with convenient connections to public transportation became a social priority. Israel Demchick, a well-known architect of apartment buildings in West Philadelphia, designed the new facility. It had more than 300 units and opened to the general community under strict federal housing guidelines in 1965.

Five

SCHOOLS

Unlike Strawberry Mansion (South Philadelphia), West Philadelphia had a neighborhood school plan, which meant that each student from kindergarten through high school would attend school in their own neighborhood, a unique opportunity. The addition of a junior high school program in the Philadelphia public school system, with its new buildings and curriculum, starting in 1929 provided an important link in the development of its students. Neighborhood schools, especially the high schools, gave the students a sense of identity and belonging in their communities. The opportunity to transfer outside of their community to Central (Boys) High School or Girls (Normal) High School to further their academic skills created another peer group. The feeling of community and the support of parents, even though many could not help their children because they were immigrants and lacked higher academic skills, encouraged their children to succeed. The educational opportunities in West Philadelphia allowed a whole generation of children to apply themselves in future endeavors as they entered the world.

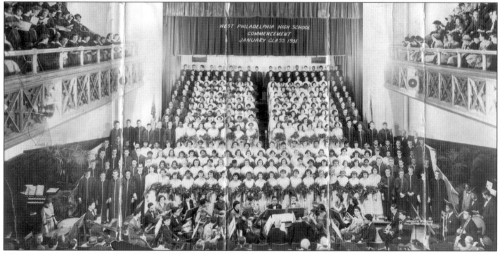

The excitement and thrill of graduating high school was more than a rite of passage—it was an honor. Sandy Finestein Siegal from Fifty-fifth and Pine Streets achieved that thrill, graduating from West Philadelphia High School in 1951. In those days, the graduating ceremonies and commencement exercises were held in the school auditorium. Today, Sandy proudly serves on the committee to organize a 50th reunion for her graduating class. (Courtesy of Sandy Siegal.)

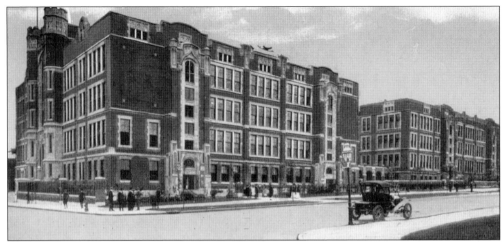

West Philadelphia High School, the first secondary school built in the community, attracted students from all neighborhoods west of the Schuylkill River in the early 20th century. This popular high school, located at Forty-seventh and Walnut Streets, continued to draw many bright students even after the construction of two additional secondary schools. (Bartram and Ovebrook) in the 1920s and 1930s. Off-campus activities were a large part of the school experience. Many students gathered at Milton Kelm's Hamburger Haven, at Forty-eighth and Chestnut Streets, to have a malted milk shake and hamburger after school. (Courtesy of the Walter Spector Collection.)

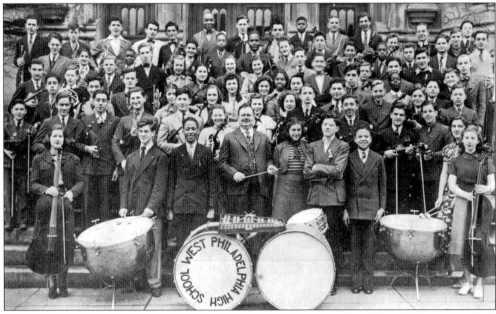

Supervised after-school activities marked a change in a student's life. West Philadelphia High School had many clubs and societies. Students with musical talent (developed over the years with many daily lessons) were joined by beginners in the school orchestra. The assortment of instruments included the violin, played by Millie Cohen Levin, who made the All-City orchestra. Originally, West Philadelphia High School contained two separate schools, one for boys and the other for girls. The orchestra was coeducational, which Levin enjoyed. (Courtesy of Millie Cohen Levin.)

The construction of new homes in Southwest Philadelphia below Baltimore Avenue in the 1920s attracted new families. Jewish residents of South Philadelphia married and migrated to the new neighborhoods; the population explosion created the need for a new high school, a modern building at Sixty-seventh Street and Elmwood Avenue built in 1939. The student body was very proud to say that they came from Bartram, especially when they won an athletic competition over their rival, West Philadelphia. (Courtesy of Carl Goldberg.)

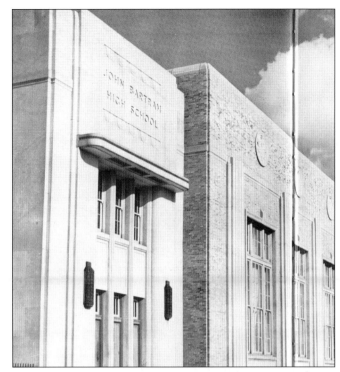

Overbrook High School, the second high school in West Philadelphia, opened in 1923 to serve students who lived north of Market Street. After World War I, going to high school was more popular; this made for overcrowded conditions at West Philadelphia High School. The athletic and academic programs allowed ordinary students to excel. The teaching staff encouraged students to achieve more each day and influenced many to apply to college. World War II interrupted this process, when many its teachers received draft notices. After World War II, all students knew the familiar face of Joe "the Soldier" Peruto, who manned a lunch truck across the Fifty-ninth Street Bridge, which connected Wynnefield with Overbrook. (Courtesy of David Gruenfeld.)

Sayre Junior High School opened its doors at Fifty-eighth and Walnut Streets on the former grounds of an abandoned brickyard (once used by the children as a play area) in the 1950s. The allegiance to one's neighborhood soon gave way to a new sense of community as students saw themselves as a part of their high school community. The popular comedian David Brenner graduated from this class and is pictured above the *S* in *Sayre*. (Courtesy of Alan Barson.)

When it opened in 1903, the William Bryant Elementary School, located at Sixtieth Street and Cedar Avenue, was called the West End school, after the name used for the neighborhood. It became the center of life for the Sixtieth Street merchants' children. Bernie Toll graduated in 1937, with Stanley Coren, Selma Shrager, Miriam Stiffel, Shirley Wilf, Morton Berger, David Margolis, Frannie Spizer, Harold Plotnick, and Sidney Grayboyes. The beloved school influenced Larry Magid's life so much that he set up a foundation to send 50 students to the college of their choice when they graduate high school. (Courtesy of Bernie Toll.)

The Dimmer Beeber Junior High School, in the west end of Wynnefield, was built in 1932. It catered to a growing number of students who lived in the neighborhood and who had graduated from the Mann Elementary School at Fifty-fourth and Berk Streets. The junior high school, at Fifty-ninth and Malvern, blended with the newly built homes, but its students stood out, especially when the 1942 graduating class went onto Overbrook High School. A student could live in a two-square-mile area and complete their education from kindergarten to high school without ever taking a school bus. (Courtesy of Janice Wilson.)

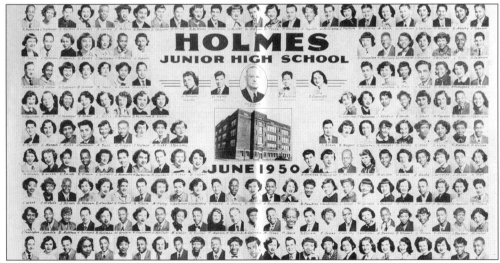

The new junior high school program developed immediately after World War I in West Philadelphia. The Holmes Junior High School at Fifty-fifth and Chestnut Streets blazed the trail for the movement to create a connection for children between grammar school and high school. Taking courses with a different teacher each period and learning to shuffle through the hallways opened all the children's minds to a different environment. The success of the program led to the closing of Holmes Junior High School in 1950, one generation after it opened its doors. The children and staff migrated to the newly constructed Sayre Junior High School at Fifty-eighth and Walnut Streets. (Courtesy of Alvin Applebaum.)

47

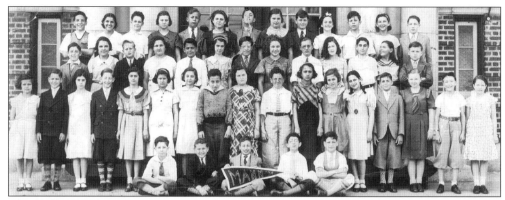

The William Mann Elementary School in Wynnefield opened in 1924. The new Har Zion Temple synagogue building opened in the same year. The Jewish community in this neighborhood was growing and created a need for the school. The Mann school included up to grade six, and students were separated into different classes, such as the A class, which graduated in January. Pictured here is the 1934 A class, which included Ethel Liebman, Gladyse Pressman, Dana Berman, Marven Gelman, Alvin Bush, Bernard Porter, and Howard Rothstein. The 1934 B class, which graduated in the spring, had Jack Weiner, Bobby Gross, Sylvia Feldstein, Izzy Milgrim, Rose Chaiken, Ethel Bombsey, Martha Novaseller, Phyliss Frank, Irma Kay (whose brother was the musician Hersehy Kay), and Clara Mayon. (Courtesy of Sid Lieberman.)

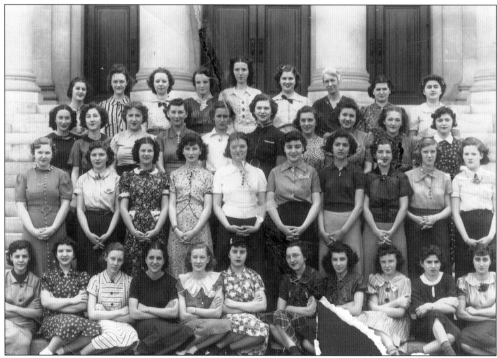

The first (1936) graduating class at Beeber Junior High School included many girls who had taken the Commercial class. The girls included Ann Slotkin, Marge Lazarous, and Goldie Lieberman Levin. Boys as a rule did not take the Commercial course. The skills learned in those classes lasted a lifetime. With the knowledge of shorthand, a young girl out of high school acquired a job immediately. (Courtesy of Sid Leiberman.)

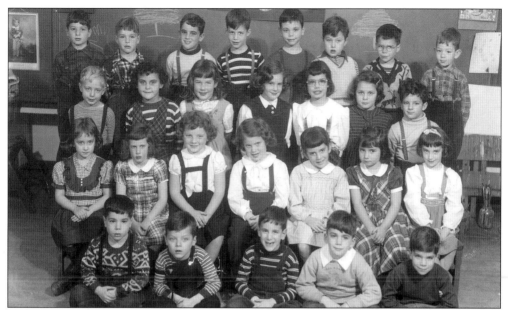

After World War II, the Mann school, at North Fifty-fourth and Berk Streets, served a second generation of children from the Wynnefield section. The kindergarten class of 1948 represented the beginning of the large population explosion duplicated across America, the baby boom. The class included Sheila Landau, Barry Minsky, Mark Saltz, Joel Levin, Rena Friedman, Phyllis Ponnick, Beverly Cohen, Barbara Rubin, and Paul Fishkin. (Courtesy of David Grunfeld.)

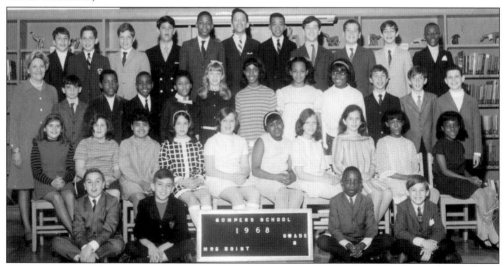

The Samuel Gompers Elementary School opened in 1950 in the upper reaches of Wynnefield to serve a growing post–World War II population. New homes built along Wynnefield Avenue and other sections of the neighborhood added to the number of students and therefore to the overcrowding at the school. The new school with its long, sleek, low-level design blended with the architecture of the surrounding streets at Fifty-seventh Street and Wynnefield Avenue. One of the last predominately Jewish classes (1968) included Saul Korewa, Jeff Taub, Larry Finkle, Dave Segal, Scott Lichterman, Bruce Levin, Randee Koch, Robin Gottlieb, and Eileen Meyers. (Courtesy of Scott Lichterman.)

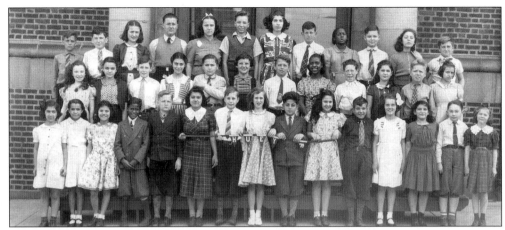

The Samuel P. Huey Elementary School, on the corner of Fifty-second and Pine Streets, served as a magnet school for children of merchants along Fifty-second Street and the garden apartment district at Forty-seventh Street. The melting pot effect allowed different economic classes of Jewish people to meet one another and develop friendships. Classmates of the 1939 graduating class included Al Nippon, Marilyn Zeldin, Anita Levin Kuptsow, Rene Rudolph, and Phyliss Waingrow. (Courtesy of Anita Kuptsow.)

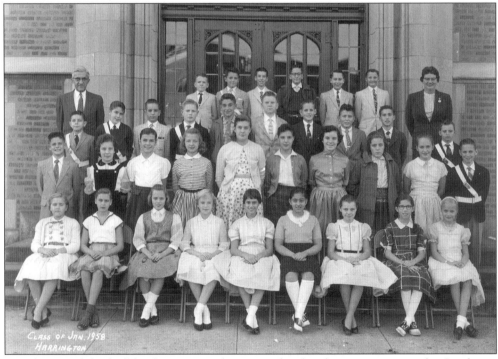

New houses of the buff brick variety with sun porches lined many streets in the Southwest Philadelphia community below Baltimore Avenue in the 1920s. Jews took up residence in the many new homes built there. Their children went to the Avery Harrington Elementary School at Fifty-third Street and Baltimore Avenue, which opened in 1927. The mix of students included children of merchants on Baltimore Avenue and the corner store owners sprinkled throughout the neighborhood. This photograph includes the safety patrol, the boys in sashes flanking the group. Being part of this group was a fun rite of passage. (Courtesy of Bruce Waldman.)

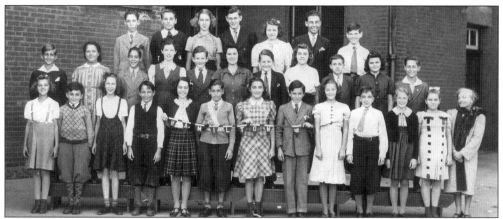

Many school photographs taken in the late 1930s with a wide-angle lens could include all the children standing on the front steps of their school. The Andrew Hamilton Elementary School at Fifty-sixth and Spruce Streets (1904) represented another case of a densely populated area within West Philadelphia, known as the West End. Other schools in the community rivaled each other for students. Enrollment boundaries for the nearby William Harrity School (built in 1913 at Fifty-sixth and Christian) and the William Bryant School (built in 1903 at Sixtieth and Cedar) split neighborhood friendships but allowed new ones to develop. The Class of 1940 at Hamilton included Len Siegel, Rudy Brooks, Phil Dansky, Stan Cohen, Sidney Feldman, Marvin Flomenhoft, and Marvin Flomenhoft. (Courtesy of Stanley Cohen.)

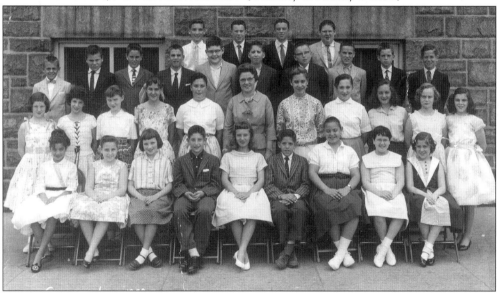

Neighborhood children (who spent so much time at Phil's Luncheonette at Fifty-seventh and Beaumont that they practically lived there) enjoyed a continuous sense of family from dawn until dusk each day in the 1930s through the 1950s. The meeting place for school activities was the William Longstreth Elementary School, located at Fifty-seventh Street and Willows Avenue. Hebrew school lessons took place at Beth Am Israel synagogue on Fifty-eighth and Warrington. Later, it was off to Phil's to eat and do some homework in the large booths. Brenda Leckerman, Alan Gurwood, Sheldon Steinberg, Alan Sharp, Netta Schwartz, and Steve Lyons enjoyed the company of Marc Greenstein, whose father operated Phil's. The whole gang graduated from the Longstreth School in 1959. (Courtesy of Marc Greenstein.)

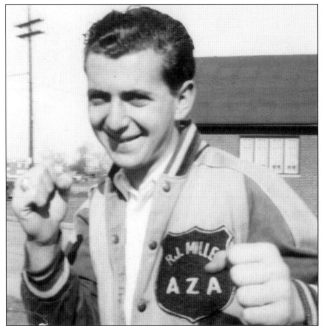

A popular way to spend time away from your family was to join the fraternities that had chapters in West Philadelphia. The American Zionist Association (AZA), sponsored by B'nai Brith, was a Jewish fraternity that held regional affairs to allow high school boys from different neighborhoods to meet one another. Sigma Alpha Roe organized in the Philadelphia public high schools immediately after 1918. Steve Cohen, from the Island Road Jewish community, belonged to the R.J. Miller chapter of AZA in 1947. (Courtesy of Jackie Ehrlich Hanover.)

B'nai Brith sponsored B'nai Brith Girls (BBG), a companion group to AZA, which made up the B'nai Brith Youth Organization (BBYO). Joint affairs brought Jewish girls and boys together in social activities while in high school. Some chapters met in synagogues such as Har Zion Temple in Wynnefield; others met in private homes and restaurants. Harry Friedman, Freida Posner, Mary Yaskin, Ed Beller, Dave Silvestein, George Koffs, and his future wife, Gloria Nomes, met at a BBYO gathering in 1947. Harry Friedman described his neighborhood (Island Road, or the Meadows) as small southern town complete with its own trolley car line downtown. This line gave Jewish high school students a chance to join these various clubs, mingle with students from all socio-economic groups, and travel around the city after World War II. (Courtesy of Harry Heshie Friedman.)

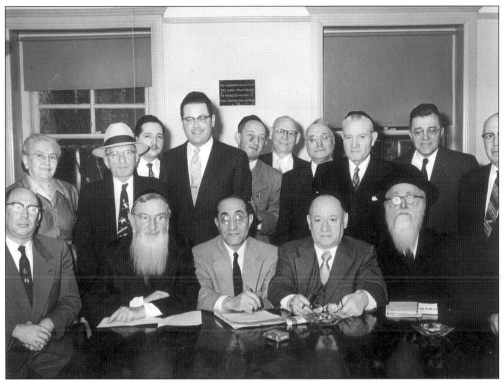

The Philadelphia Talmudical Yeshiva, founded in the 1950s, was originally located at Thirtieth and Berk Streets in the Strawberry Mansion section of Philadelphia. Some notable figures in the community are shown as they plan their third annual banquet (1960). They include Rabbi Ephraim Yolles, Ben Kurman, Nathan Perilstein, Rabbi Noviseller, Rabbi Wohgelinter, Joseph Berman, and Rabbi Ryback. The Philadelphia yeshiva is a secondary school institution, highly acclaimed for its academic standards. (Courtesy of the Philadelphia Jewish Exponent.)

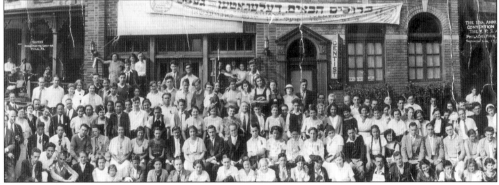

West Philadelphia had an assortment of Jewish schools run by arms of different ideologies prevalent in the 20th century. The Jewish community of Fortieth Street and Girard Avenue was a hotbed of activity that included the Hebrew Sunday School Society, the Workman Circle school, private Hebrew schools, *cheder*, and the Young Zionist Alliance, which sponsored a fundraiser for education in Palestine. Noted guest Golda Meir, a Russian Jew and American-raised youth form Minnesota, is seated in the second row from the bottom, nine people from the left. Picnics in the nearby Fairmount Park gathered speakers from across America to congregate. (Courtesy of Millie Goldberg.)

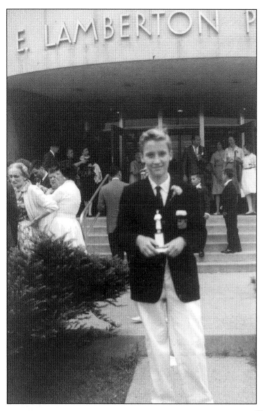

The Robert Lamberton Elementary School, at Seventy-fifth and Woodbine, was built in 1949. The school served two generations of Jewish children in the Overbrook Park section, in the upper northwestern reaches of western Philadelphia. Alan Silverstein received the Jewish War Veteran Post No. 148 Rippen-Bazell (from 7500 Brookhaven Road) Award, a scholarship, when he graduated Lamberton in 1960. His sister Janice Wilson and her husband, Art, have deep roots in Wynnefield and Overbrook Park and moved to Overbrook Park after their marriage in 1976. The Wilsons' children Ariel and Jonas graduated Lamberton in the 1990s. (Courtesy of Janice Wilson.)

Dorothy Moskowitz Orwitz, a graduate of Penn State College (1945), migrated to Overbrook Park when Supio's Nursery had goats and muddy paths on its large property. Most of the nearly 2,000 homes in the one-and-a-half-square-mile Overbrook Park were under construction during the late 1940s. Dorothy raised her son Jonathan at 7546 Woodbine Road, directly across from the Lamberton Elementary School. Dorothy knew Emil Wolf, a principal at Lamberton who followed the students to become principal at Beeber Junior High School in Wynnefield. Another colleague, a Mr. Ramono (principal at Lamberton), created the neighborhood high school environment, which was crucial to stabilizing the community, by allowing students to remain in their own neighborhood for high school. Dorothy volunteered to substitute for teachers at Lamberton; five years later, in 1969, she formally became a reading teacher. In the 1980s, she developed a practice test for students who took the Iowa and California achievement tests.

Six

FUN AND RECREATION TIME

Jewish life in West Philadelphia meant staying in your own neighborhood and finding things to do with people who had similar interests. The opportunity to pal around with your friends was unique to this community, which was spread over a large geographical area. The venues, whether sports or entertainment, were located throughout West Philadelphia. The extended family atmosphere, combined with easy access to public transportation, made West Philadelphia a terrific place to grow up. Memories of seasonal activities are still vivid in many people's minds 40, 50, and even 60 years later.

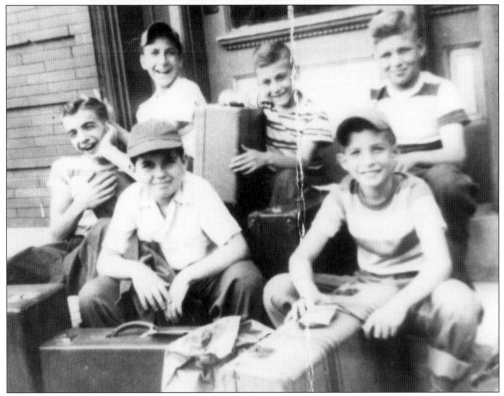

There comes a time in every boy's life when the apron strings are broken. The first fight in the neighborhood is usually that initiation into manhood. Another important rite of passage is going off to an overnight camp away from Mom's good cooking. On this occasion, the whole neighborhood is invited to tag along. The merchant's children from the Sixtieth Street business shopping area gather in front of Kaplan's shoe store. The six boys—Mike Kaplan, Jerry Wurtz, Larry Miller, Ivan, Eddie, and Bernie Elias—are all packed for the trip into the countryside to Samuel Goldman Freedman (SGF) outside of Norristown in the 1950s. (Courtesy of Mike Kaplan.)

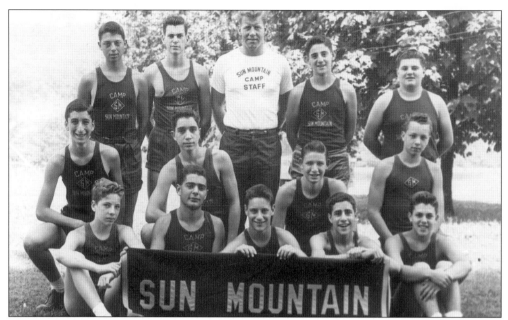

The smell of the fresh air in the Pocono Mountains is what Carl Goldberg, the son of a Sixty-third Street and Woodland Avenue merchant, remembers the most from his first day at Sun Mountain Camp in East Strousberg, operated by Moe Weinstein, Harry Litwack, and Jimmy Dessen. Thirty Jewish-owned and Jewish-operated summer retreats adopted a variety of names, most which were Native American in origin. The overnight camping experience usually lasted two weeks, if your parents could afford it, or at least one week for tighter budgets. (Courtesy of Carl Goldberg.)

Each year, the anxious children of West Philadelphia cleaned their rooms, neatly straightened their closets, and placed their bicycles in the basement or garage with white sheets over them in preparation for their departure for summer camp. Supervised activities were the order of the day at the popular Pine Forrest Camp, in the Pocono Mountains, only a two-hour drive away. Baseball, swimming, hiking, fishing, and camping in the woods made one very hungry for supper. Usually, campers finished everything on their plates, unlike at home. (Courtesy of Carl Goldberg.)

The Philadelphia region enjoyed a great number of summer camps all within a 50-mile radius. Camp Arthur and Reeta, a summer camp for Jewish boys and girls, was 40 miles from West Philadelphia. The facility, tucked away off Route 29 in Zieglersville, northwest of the city, catered to children whose parents had little means to pay for camp. The parents paid the fees by saving all year long—their reward being their own vacation in homes they had all to themselves. The Jewish flavor of the camp was reflected by the counselors leading prayer services before breakfast. Joel Spivak went to the same camp four years in a row and, like many other children of his age, wrote the names of his camp buddies right on the photograph so he would not forget them the following year. The children received a bonus with their admittance to Camp Arthur and Reeta—a free membership to the YMHA downtown at Broad and Pine Streets. (Courtesy of Joel Spivak.)

Melrose Hall Day Camp, a tradition in Wynnefield dating from the 1930s, was a place where Jewish children romped and played with other Jewish children their own ages. Gwen and Adolph Caplen took over management of Melrose Hall, a year-round school, in the 1950s, assisted by Lou Scherr and Meyer Heiman, who operated camp Saginow in the Pocono Mountains. Melrose Hall had a reputation as a premier neighborhood institution that ran an excellent summer program. June Caplen Kurtz, the flaming redhead pictured here, taught pre-kindergarten during the school year and assisted Gwen Caplen in the summertime. Less than a year after this photograph was taken, June passed away and was sadly missed by her family and students. (Courtesy of Bobby Caplen Shaffner.)

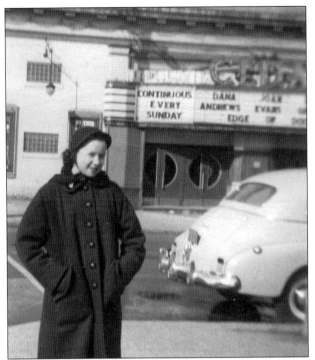

The Cedar Theater at Sixtieth Street and Cedar Avenue, a neighborhood institution for many years, catered to the children in the area. On Saturday afternoons in the late 1940s, it was packed with yelling and screaming children running everywhere to get a good seat before their favorite cowboys came to the silver screen. Some children even smuggled in hot knishes from Dash's Deli—only the aroma gave them away. Right after the four-hour episode, it seemed as if the whole theater would go to Barson's ice-cream store and restaurant, located on Sixtieth Street. (Courtesy of Alan Barson.)

The Imperial on Sixtieth Street near Market Street attracted children from the entire community for blocks around. To get a ticket on a Saturday afternoon required waiting in a line that stretched the block. Several other movie houses did a good business in the same area. They included the Mayfair and the Crosskeys. Years later, the Imperial was turned into a roller-skating rink.

Vaudeville acts, where the actors were accompanied by musicians, entertained a fully packed Nixon Theatre at Fifty-second and Market Streets. The young audiences had to interpret the scenes themselves. Then, in the 1930s, the talkies replaced the silent motion pictures with four to six hours of entertainment on Saturday and Sunday afternoons. The popular movie houses included the Crescent at Eighty-fourth Street and Eastwick Avenue, the Benn at Sixty-Forth and Woodland Avenue, the Mayfair on Market Street at Sixtieth, the Sherwood on Baltimore Avenue, and the Wynne on North Fifty-fourth Street. As a child, Carl Goldberg kept his ticket stubs to prove to his mother where he had spent his afternoons. (Courtesy of Carl Goldberg.)

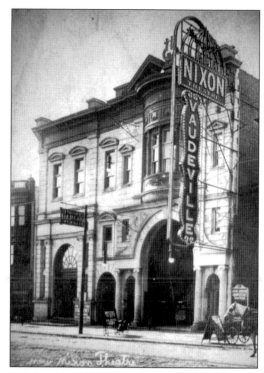

The major crossroad in West Philadelphia, Fifty-second and Market under the El, became the best place in West Philadelphia to watch a first-run movie. The Locust Theater attracted people from the West End, Wynnefield, Island Road, and the Garden Court District. The collection of the Nixon, State, and Capital theaters on Fifty-second Street provided many viewers with a wide array of entertainment from the 1920s through the 1950s.

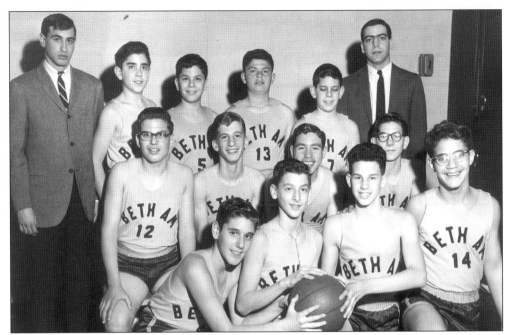

Sports played a big role in the development of Jewish students in the religious schools and institutions throughout West Philadelphia. The conservative synagogues sponsored Jewish basketball teams, which played in the United Synagogue Youth league. Beth Am Israel built a social hall along with its new school building and encouraged teams to form. The Beth Am Israel team, which beat Har Zion Temple in 1963, included Larry Grossman, Joey Glazer, David Goldner, Bruce Love, Martin Milner, Larry Frank, Leonard Brown, Joey Rosen, Alan Shulsky, and Eddie Katz. (Courtesy of the *Jewish Exponent*.)

The Savitz Brothers drugstore, at Fifty-eighth Street and Woodland Avenue, served as a landmark between West and Southwest Philadelphia. Connections to and from the areas south of Woodland Avenue and heading north on Fifty-eighth Street made this corner a popular destination. The Savitz soda fountain was legendary for its malted milk shakes. The business was founded in the 1930s by Percy and Sara Savitz from Strawberry Mansion and South Philadelphia. The soda fountain was added in the early 1940s and Jules and Leah Savitz joined the team. The business closed in 1972. (Courtesy of Barry and Ellen Savitz.)

Team sports and Jewish children went hand-in-glove, especially at the new Sayre Junior High School, located at Fifty-eighth and Walnut Streets. The eighth-grade baseball team in 1956 included Bob Feldman, Howie Hirshbaum, Ed Kornstatdt, Dave Elfont, Larry Magid, Harvey Smith, Irv Gurwood, and Bruce Berkowitz. The team, coached by Mr. Drozd, won the city junior high championship with 17 wins and only one loss. (Courtesy Larry Magid.)

Jewish football players at the varsity level in high schools throughout West Philadelphia were a rarity—except for David Perelman, who played on the 1951 West Philadelphia football varsity squad. Other Jewish sportmates included Robert Brownstein and Joel Wattenmaker. A previous star Jewish athlete on the football team had been Bo Rosenbleeth, who received a scholarship to the University of Pennsylvania. Some students who came to West Philadelphia High School did not live in West Philadelphia. David fit into this category since he lived at Fifth and South Streets and chose to attend West Philadelphia High School and took the No. 42 trolley car straight to school. (Courtesy of Betty and David Perelman.)

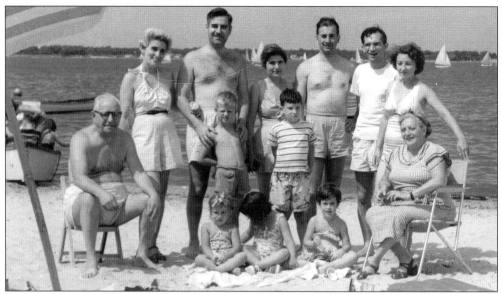

Heading down the shore, usually on the beaches of Atlantic City, was a ritual for many Philadelphia Jewish families. Atlantic City was known as the "lungs of Philadelphia" well before the invention of air conditioning. The Ceilan family poses with the newly transplanted Mozenter family from Sixtieth Street and Osage Avenue and the Hall family. The group includes Ben, Fay, George, Edith, Gary, and Ann Celian; Paul, Sofie, Celia, and Jerry Mozenter; and Meyer, Nancy, and Sylvia Hall. The Mozenters were from Monroeville, New Jersey, a Jewish farming community some 40 miles south of Philadelphia. This great family photograph dates from the late 1940s. (Courtesy of Walter Spector.)

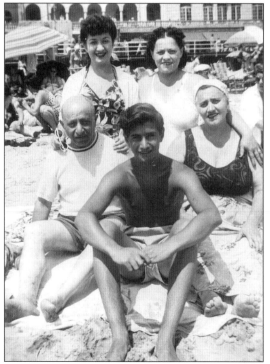

The long hot summers in Philadelphia gave business families a chance to relax and get away at the same time. The store owners usually closed up shop, in the first week of July, when the temperatures in the city peaked at over 90 degrees. Extended families went to the Jewish hotels in Atlantic City, at the edge of the Atlantic Ocean, only 60 miles away. The Stein's Royal Palm Hotel attracted many families. The whole *mispocha* (family) escaped the hot grill at Phil's Luncheonette, in Southwest Philadelphia, and took in the beach down at the shore. They include Harvey, Milt, Lena, and Stella. (Courtesy of Stella Cooperstein Greenstein.)

Crystal pool, located near Woodside amusement park, along the western banks of the Schuylkill River, provided instant relief from the summer heat. The venue had a Spanish motif to reflect a faraway place and catered to a large young audience. Eugene Dichter, from Fortieth Street and Girard Avenue, took the Park Trolley, which ran through Fairmount Park, to meet his cousin Irene Levin, who lived in Strawberry Mansion. Irene rode the same trolley, which had a terminal in Strawberry Mansion. (Courtesy of Eugene Dichter.)

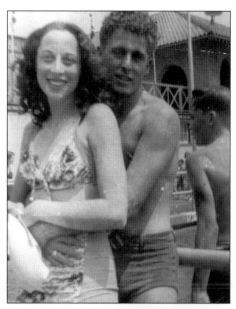

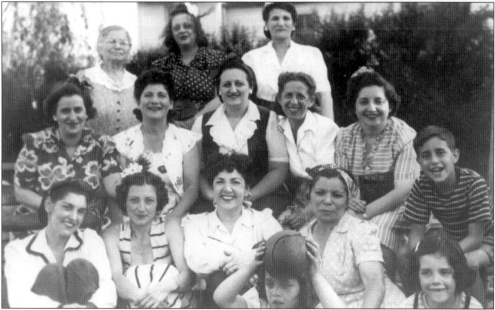

Family time meant more than outings for many West Philadelphia Jewish families. Taking group pictures featuring striking poses with as many people who could jam into the view of the camera's lens as possible became a tradition in many families. The family scrapbook, complete with picture mounts, was another tradition of American Jewish families, as the Kodak Brownie Six, a compact box camera, entered the market. The Goldberg family from Woodland Avenue in Southwest Philadelphia vacationed annually in the Jewish resort area of Collegeville, some 40 miles north of Philadelphia in Montgomery County along Routes 422 and 29. The Krekstein's farm featured cottages and became a popular place to spend a summer away from the heat of the city. Many Jewish-owned farms around Philadelphia opened their doors for *pleasurniks* (pleasure seekers) similar to resorts in the Catskill Mountains in upstate New York. (Courtesy of Carl Goldberg.)

Concourse Lake, a man-made wading pool on the grounds of the famed Centennial Exposition at Fortieth Street and Girard Avenue, provided a scenic and romantic place to take a date. The venue, which featured acres and acres of lush parkland and concrete walking paths, had many activities and places to visit for a full-day trip and was easily accessible by public transportation. During the winter, the lake froze over and ice-skating became the popular pastime. (Courtesy of Stella Greenstein.)

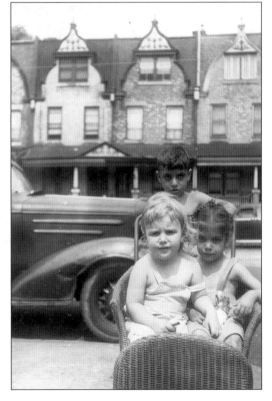

Found memories in Parkside include young children sitting in a coach or stroller. The ride and the view of the neighborhood and Fairmount Park are forever etched in the mind of Diane Bush Berman. Murray Bush, Diane's brother, is standing in back of the coach with Diane's friend Rochelle. The children played on George's Hill, at the statue of Moses, and at Concourse Lake, all of which were near Fifty-second Street and Parkside Avenue. The stroll up Fifty-second Street included the aromas of Diane's grandparents' bakery, Edstein's, William Leibowitz's and Harry Luboff Kosher Meats, Spliller's Luncheonette, Tudy's Fruits, and Woodnick's Beautyshop. Diane loved to help her Bubbie, Katie, and Zada, Nathan, fill the doughnuts with jelly in the bakery, especially during Chanukah. (Courtesy of Diane Bush Berman.)

Seven
THE BUSINESS DISTRICTS

Each neighborhood in West Philadelphia had its own business district, whether small or large. The small-town mindset lent itself very well to the concept of a central market, as in the case of the Sixty-third Street and Woodland Avenue shopping district, where the Jewish population lived above their stores. In West Philadelphia's grand shopping district of Sixtieth Street in the West End area, whole facades were changed into storefronts beginning in the second decade of the 20th century. The Fortieth Street and Lancaster area began as a country-to-city crossroads with a general farmers' market. Jewish shopkeepers had plenty of company to schmooze with when business was slow. Some Jewish sections grew up around new synagogues (Har Zion Temple), such as the Wynnefield shopping district on North Fifty-fourth Street in the 1930s. Most people worked 12 to 14 hours daily, and some who kept kosher had to deal with non-kosher products in order to sustain a living. By the 1970s, however, declining Jewish neighborhoods spelled the end to family business, as many merchants retired, moved away, passed away, or just walked away from their businesses because their properties were worthless. Surprisingly, one can take a tour of the community today and find some Jewish-owned businesses that managed to survive.

At one time, the Sixtieth Street shopping district contained more than 100 businesses, most of which were owned by Jewish merchants. The business district stretched from one block north of Market Street to seven blocks south of the famed Market Street El stop. Expansion to the West End (as the neighborhood was called when the El was built in 1908) grew as newly arriving Jewish immigrants looked for sections of Philadelphia to start a business and raise a family. Sixtieth Street had everything, from buttons to exotic birds, to the New York and American bargain stores. The Goodstein family, Herman and Eva, who owned the Overbrook Furniture Company at 6123 Market Street, lived upstairs with their children Sidney, Milton, and Sylvia.

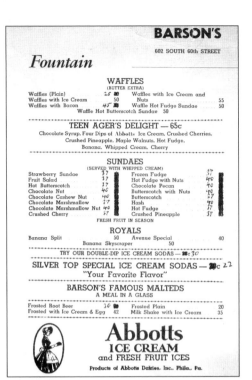

BARSON'S

602 SOUTH 60th STREET

Fountain

WAFFLES
(BUTTER EXTRA)

Waffles (Plain)	25	Waffles with Ice Cream and	
Waffles with Ice Cream	50	Nuts	55
Waffles with Bacon	45	Waffle Hot Fudge Sundae	50
		Waffle Hot Butterscotch Sundae 50	

TEEN AGER'S DELIGHT — 65c
Chocolate Syrup, Four Dips of Abbotts Ice Cream, Crushed Cherries.
Crushed Pineapple, Maple Walnuts, Hot Fudge,
Banana, Whipped Cream, Cherry

SUNDAES
(SERVED WITH WHIPPED CREAM)

Strawberry Sundae	37	Frozen Fudge	37
Fruit Salad	37	Hot Fudge with Nuts	40
Hot Butterscotch	37	Chocolate Pecan	40
Chocolate Nut	40	Butterscotch with Nuts	40
Chocolate Cashew Nut	40	Butterscotch	37
Chocolate Marshmallow	37	Hash	40
Chocolate Marshmallow Nut	40	Hot Fudge	37
Crushed Cherry	37	Crushed Pineapple	37

FRESH FRUIT IN SEASON

ROYALS

Banana Split	50	Avenue Special	40
	Banana Skyscraper	50	

TRY OUR DOUBLE-DIP ICE CREAM SODAS — 30c

SILVER TOP SPECIAL ICE CREAM SODAS — 22c
"Your Favorite Flavor"

BARSON'S FAMOUS MALTEDS
A MEAL IN A GLASS

Frosted Root Beer	30	Frosted Plain	20
Frosted with Ice Cream & Egg	42	Milk Shake with Ice Cream	35

Abbotts
ICE CREAM
and FRESH FRUIT ICES

Products of Abbotts Dairies, Inc., Phila., Pa.

Leon and Reba Barson arrived in America in the early 1900s and lived at Fifth and South Streets, until they migrated to West Philadelphia to open the famous Barson's eatery in 1942. Their eatery was so beloved by the neighborhood that they made it an institution for all types of daily rituals—before school, for lunch, and after school. It was also popular after watching a movie at the Cedar Theater, across Sixtieth Street at Cedar Street. The menu featured Abbott's ice cream and traditional Jewish sandwiches of corned beef and pastrami, with lots of pickles on the side. (Courtesy of Alan Barson.)

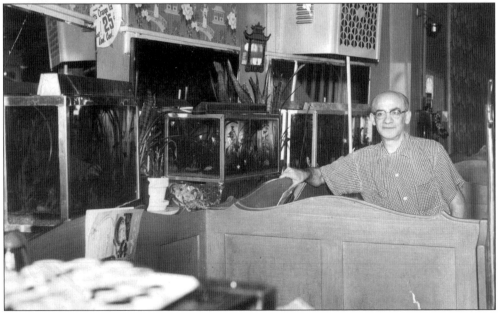

Each successful restaurant in Philadelphia has relied on a theme to attract more customers. Leon Barson, who operated Barson's Luncheonette during the 1940s at 602 South Sixtieth Street, was proud of the *haimish* (homey) atmosphere of the place, complete with many 50-gallon fish tanks filled with live tropical fish. The restaurant seated 250 people in a double storefront. The whole family lived upstairs and helped to operate the restaurant. When extra help was needed, Leon rang a bell, which alerted the family to join in the activities in the dining room. (Courtesy of Sam Barson.)

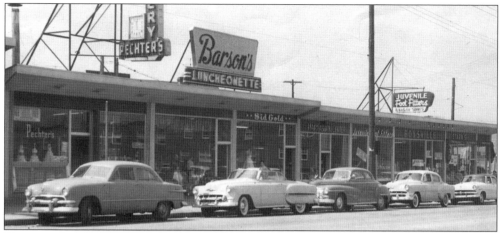

The appeal of Barson's name for Jewish delicatessen became very popular and sought after in the 1960s. The move and expansion to Overbrook Park allowed Sam, one of Leon Barson's sons, to make a name for himself along Haverford Avenue. The new family dwellings built by the Warner West Company on undeveloped land (viewed as the suburbs yet within the city limits) became home to many of Barson's clientele. The neighborhood bulged with other retail outlets, including Pechter's Jewish Bakery, Sid Gold's Juvenile foot outfitters, Lubeck Shoes, Boyville, Halpern, and Bond Clothiers. (Courtesy of George Goldstone and Herb Yentis Reality Company.)

The Barson magic and know-how in the deli and restaurant business led to their success. They opened 11 operations between 1960 and 1990 throughout West Philadelphia; Overbrook Park; Wynnefield Heights; the Main Line and the western suburbs; and Northeast Philadelphia and Cherry Hill, New Jersey. Many Barson family members joined in the family tradition to serve quality food in a clean place with lots of "Jewish-style" attention to service. Sam's wife, Freddie, joined with the Glassman family from Wynnefield to open the Wynnefield Heights restaurant in the middle of the high-rise apartment buildings at 3901 Conshohocken Avenue. Today, the third generation, Louis Barson, follows the tradition by overseeing restaurant operations. (Courtesy of Sam and Freddie Barson.)

Dash's Deli, known for its wholesome knishes and gefilte fish, was a pioneer merchant on Sixtieth Street in the 1930s. Gertrude Dash took the suggestion of a family member to bake knishes, which were piled in a triangle on a heated plate in the window for all to see and smell. David Brenner, the famous comedian who grew up in the neighborhood, traded woodwork creations from the wood shop at the Bryant Elementary School for knishes on a regular basis. The knishes, with a light flaky crust and meat or potato filling served hot, satisfied anyone's craving for good food. The popularity of knishes will never disappear according to Yetta, who served as president of the West Philadelphia chapter of Hadassah that met at Congregation Beth El at Fifty-eighth and Walnut Streets, the sponsor of Dollars for Scholars, catered by Mrs. Dash. (Courtesy of Yetta Dash Weinberg.)

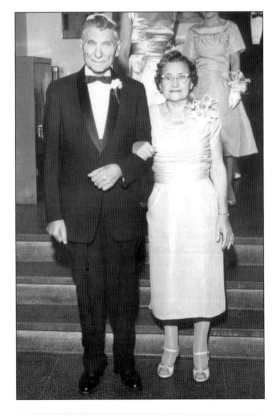

The I. Krapp Hardware merchants (Israel and Jennie) belonged to a prestigious group of business owners on South Sixtieth Street during the 1950s. These businesses included Ginberg's Bicycles, Potaminkin Fish Market, Chasin Drugstore, Beckman Furrier, the Pink Shop, Dorfman Clothing, the Cinderella Shop, Izzie the shoemaker, Litvin's ladies hosiery, Waxler's Deli, London paperhangers, the Pine public baths, Mo's candy shop, Weinberg's fruit store, and many others. The hardware store carried the hard-to-find self-locking eyes and hooks, which prevented old wooden playpens from collapsing. (Courtesy of Sofie Krapp Pomerantz.)

Labove's featured homemade meals for young men posed to enlist in the armed service during World War II. Jack Whitman, Stanly Cohen, and Allan Rogaff hung out at Labove's every day for years. The boys learned the ways of the street by associating with other guys who frequented Benny's poolroom, which was up Sixtieth Street. Sixtieth Street is where people four or five thick strolled the sidewalks every day as they shopped at Zakian Drugstore, Herman's Trimming Store, Waxler's Deli, Rossoff's Drugstore, Blanks candy and cigars, and Golub's Grocery. (Courtesy of Stanley Cohen.)

You could find anything and everything on Sixtieth Street without even going downtown to the central shopping district. The green Depression dishware made a big comeback in the 1950s, and Abe, the proprietor of A–Z Hardware, carried many sets. Fellow Sixtieth Street merchants included Rosen Electric, Mitchell the plumber, Levitt Plumbing, Sklar paints, Solaway Hardware, Zukerman's Flexir Electric, the Marback ice-cream parlor, Bralow's Fish Market, Herb Zingler, Levin's Drugstore, Granoff's Lamps, Amrom's fresh fish, Rouner ladies' wear, Freed's butter and eggs, Shiner's Candies, Mayer's ice-cream parlor, and at least one deli. Many years later, A–Z is still open and operating under the same name.

The usual cost for a haircut in the 1950s amounted to 25¢. Manny Levine's father, Fred, operated the Community Barbershop on 400 South Sixtieth Street from 1938 to 1959. The sanitized shop boasted of five barbers; all the chairs were filled daily, especially after the Bryant Elementary School on Sixtieth Street let out for the day. Other merchants nearby included Dash's wholesale tobacco, Zeke's Pharmacy, Baron's appliances, Nu Cedar Drugstore, Weinstein kosher meats, Mom's Luncheonette, and Waxler's Deli. (Courtesy of Manny Levine.)

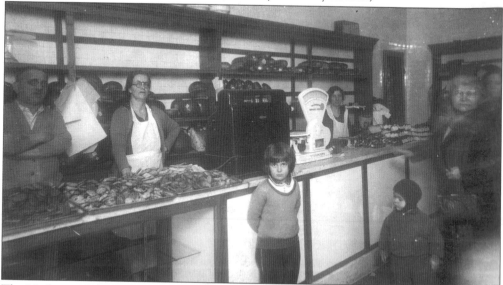

The Moskowitz Bakery Shop at 435 South Sixtieth Street baked some of the most delicious rye bread in all of West Philadelphia as early as the second decade of the 20th century. Isador and Jennie, the proprietors, came from Warsaw, Poland. The couple met and married after departing from ships that docked in South Philadelphia, where they stayed before coming out to the West End. They selected the double property for the bakery near the Bryant Elementary School to raise their daughters Lilian, Dorothy, and Minnie. (Courtesy of Dorothy Moskowitz Orwitz.)

West Philadelphia had numerous shoe shops, but none more popular or loved than Shapiro's at 215 South Fifty-second Street near Market Street. Marty Shapiro and his wife opened the store, which specialized in orthopedic shoes for children, in 1938. They lived upstairs, atop their double storefront, like most merchants of their time. Shapiro's is still open for business. (Courtesy of Mel Schwartz.)

The fabulous Horn & Hardart's chain restaurant, a beloved institution widely patronized by the Jewish community in all parts of the city, had several locations in West Philadelphia. The biggest store, at Fifty-second Street under the Market Street El stop, catered to shoppers, lunchtime crowds, and moviegoers around the clock. Ralph Bencker, a well-known architect, designed this landmark and the nearby the Garden Court Plaza apartments at Forty Seventh and Pine Streets. The marble floors became a trademark of Horn & Hardart's. (Courtesy of the Bob Skaler collection.)

Left: Wooden frame storefronts lined Woodland Avenue with large display windows on both sides of an entryway. Sam Kaplan made delicious homemade candy in the same fashion that his father in Poland had taught him. This store was located at 6234 Woodland Avenue. (Courtesy of Elayne Kaplan Smiler.) *Right:* Harry and Annette Klighoff Goldberg, both of South Philadelphia, migrated to Southwest Philadelphia to open Goldberg's window shades and oilcloth business at Sixty-third Street and Woodland Avenue in the early 1940s. Jewish merchants lined both sides of Woodland Avenue from Sixty-second to Sixty-seventh Streets. Today, the Goldberg name is still evident in Southwest Philadelphia and Northeast Philadelphia. (Courtesy of Carl Goldberg.)

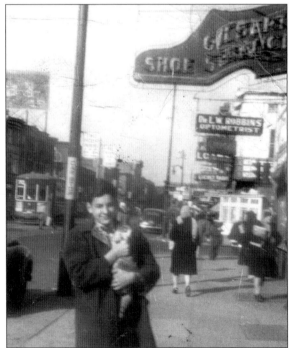

Malcolm Zeldin—son of Fred and Sarah, who owned a dress shop at 209 South Fifty-second Street—pose for a picture in 1942. Jake and Ella Zeldin ran another dress shop at 249 South Fifty-second Street. Both sides of Fifty-second Street, which stretched for five city blocks, had many Jewish merchants. (Courtesy of Malcolm Zeldin.)

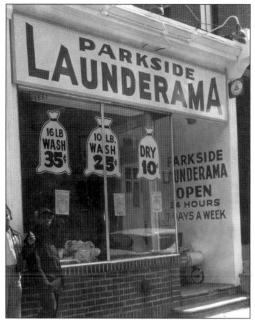

מיטשעל
גראסמאן

4002
דזשיראַרד
עוועניו

גראָסטער
דעליקאַטעסן
סטאָר
אין שטאַט.

באַנגריסט
די שול־וואָד

Left: The emergence of the coin-operated laundry in the Parkside section at 1709 North Forty-second Street came along in the 1950s thanks to the hard work of Max Weinstein, the owner and a plumber. (Courtesy of Cecilia Weinstein Rothmel.) *Right:* Mitchell Grossman, the proprietor of Grossman's Delicatessen at Fortieth Street and Girard Avenue, entertained his customers by playing his violin in the restaurant. (Courtesy of Mollie Greenberg.)

This famous corner at Forty-second Street and Leidy Avenue in the Parkside section represented a piece of Jewish Americana. It was home to Ring's Pharmacy, Green's tailor shop, and Max's fruit store. Directly across from the former grounds of the Centennial Exposition in Fairmount Park off Fortieth Street and Girard Avenue, the corner opened up into a town square with shops lining either side of the 1700 block of North Forty-second Street. (Courtesy of Bert Actman.)

Left: Jewish business owners often took time off to celebrate American holidays and to participate in featured events. Golda and Abe Ostrow, owners of a corner store at Fifty-seventh and Christian Streets, and their granddaughter Rhea Longer enjoy watching a parade on Memorial Day 1943. (Courtesy of Rhea Longer Appelbaum.) *Right:* Corner store merchants made up the bulk of businesspeople in West Philadelphia. Herman and Freda Levine operated a corner store, with their parents, who had come from Russia and who lived above the store at Fifty-fifth and Delancey Streets. Sol and Sam Zukerman supplied the Levines with wholesale provisions for Passover, including cases of matzo and all kinds of hard candies. (Courtesy of Anita Levine Kupstow.)

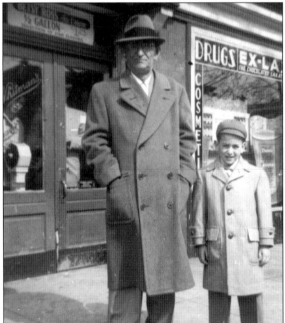

Many Jewish people made a living as pharmacists after the Great Depression. Sid Waldman opened his drugstore at Fifty-fifth and Whitby Streets in 1947 after graduating the Philadelphia College of Pharmacy. The neighborhood supported other drugstores, such as George Serlick's, Sam Reese's, Phil Brill's, and Mr. Brosky's. Bruce Waldman, the pharmacist's son, married his high school sweetheart, Eileen Nathans. (Courtesy of Bruce Waldman.)

Neighborhood children Michael "Pickles" Zarlett and Howie Rubin and Phil's Luncheonette owners' sons Marc and Dennis Greenstein cooked the famous steak royal, a hearty sandwich on a toasted hoagie roll with lettuce, tomato, onion, and cheese. Even other shop owners on Chester Avenue came to Phil's. (Courtesy of Dennis Greenstein.)

The inside of Phil's Luncheonette holds many memories. Entertainment stars such as David Brenner came from across Baltimore Avenue to hold court and tell funny stories. Other regulars were Kenny Berkoff, Ed "Zombie" Sondberg, Harold "Beans" Kootchik, Arrnie "Satin" Silver of the famed Dovel singing group, Bobby "Needles" Needleman, Saul Schwait, and the singing group Danny and the Juniors. On Tuesday nights, Phil's closed and meetings of the Corporation, a Jewish lending society with Duke Berkoff as its president, discussed distributing dividends to its members. (Courtesy of Estelle Cooperstein Greenstein.)

Abe Sellers, one of four brothers (Abe, Frank, Josh, and Albert) survived the Holocaust and arrived in the city from Felderfink Displaced Persons Camp in the late 1940s. Abe married Shyra and migrated to West Philadelphia near Forty-fifth Street and Lancaster Avenue, where they opened Abe's corner grocery market at 4540 Merion Street and operated it until 1965. The neighbors loved Sellers, who carried many of their purchases "on the books" as charges. The family lived above the store but moved to Wynnefield in the 1950s. They later retired to Northeast Philadelphia. The grocery store was razed in the 1980s. (Courtesy of Marvin Sellers.)

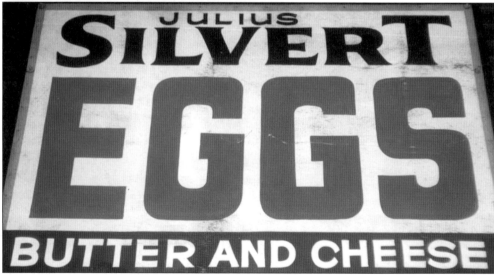

Julius Silvert, an immigrant from Russia, came to America in the early 1900s as child. He attended the Jewish Farmers College in Doylestown, started by Rabbi Krauskopt of Congregation Keneseth Israel. During the Great Depression, Julius opened a dairy store near Fortieth Street and Lancaster Avenue where farmers from Lancaster County came to sell their farm products. Julius's wife, Rebecca, candled eggs—that is, she looked for imperfections and then packed them. Brown eggs from Rhode Island red chickens were a Jewish favorite during World War II, when eggs were bought with ration stamps. The business survives and is much larger today, only recently closing its original outlet. (Courtesy of Steve Sorkin.)

The neighborhood around Fortieth Street and Lancaster Avenue is not generally considered a Jewish neighborhood, but the collection of 60 businesses there were owned by Jewish people from the 1930s through the 1950s. Kay Electric was joined by Manusov self-service supermarket, which opened in 1946, the first of its kind. Merchants from businesses such as Segal's Drugstore, Wolff's Bicycles, Danzig the Leader movie theater, Romain Housewares, Sun Ray discount drugstore, Brownsteins Bakery, and Hellers pharmacy mainly sent their children to the Hebrew Sunday School Society at 4024 Lancaster Avenue.

New Deal Lumber, at Fifty-second Street and Lancaster Avenue, was founded in 1934 at the height of the Great Depression (which is how it gained its name). The new building supply company, organized by Meyer Madway and Hyman Farbstein, met at the Wynnefield gas station (at the corner of Fifty-seventh and Upland Way) and consummated the deal with a joint $5,000 deposit for supplies. The sons of both founders, Sol Farbstein and Hillard Madway, ran the enterprise until 1949, when Madway sold his interest and became a builder of homes and apartment buildings (the Greenhill Apartments on City Line Avenue). The business today is run by Scott Miller (a son-in-law) and Scott Farberstein (a grandson of Hyman).

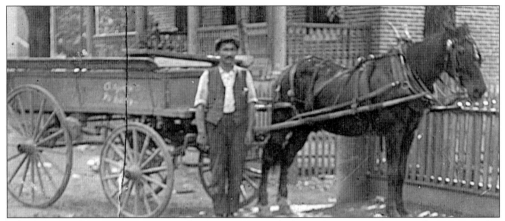

Abraham Yaskin, an immigrant from Russia, settled in the Eastwick area, known as the Meadows section of Southwest Philadelphia (as the Island Road Jews referred to their area). Jewish families from there welcomed Yaskin from the his arrival in the late 1890s as a member of the community. Assisted by the Hebrew Immigrant Aid Society, he became a plumber, operating around the neighborhood with a horse and wagon from his residence at 7925 Harley Avenue. He made his journeys without the fear of pogroms, from which he had fled in Russia. Yaskin helped to build the community, which had little running water and relied on outhouses well into the 1920s, when electricity and telephone service came to the area. He felt at home in his newly adopted *shtetl* (urban village) and belonged to the Eightieth Street and Harley Avenue synagogue, Agudas Achim. (Courtesy of Ben Cohen.)

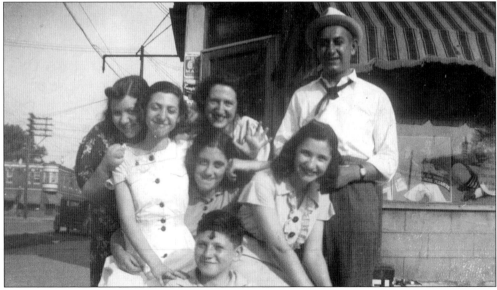

Bunk's grocery store, in the Island Road community of Southwest Philadelphia, opened in the Meadows at Eighty-fourth Street and Eastwick Avenue in the second decade of the 20th century. Sylvia, Emma, Zelda, Martin, and Sarah Cherry join Lilly and Aaron Bunk for this memorable pose. The children went to the Wolf School at Eighty-second and Lyons Avenue. Large families were related to each other in the community, including the Cherrys, the Levins, the Bunks, the Cohens, and the Entlis. The Eighty-fourth Street Synagogue, Atereth Israel, and the two dozen stores along the No. 37 trolley car line made up the center of Island Road's friendly Jewish community. (Courtesy of Fran Cohen Weiss.)

Apollo Hosiery (located at 1311 North Fifty-second Street where it crosses Girard Avenue) was owned by Morris and Anna Levin Weinstein and was opened in 1940 when they came to West Philadelphia by way of Woodbine, New Jersey, and South Philadelphia. A sinkhole the size of half a block stopped all vehicular traffic on Fifty-second Street above Girard Avenue during World War II. This gave the shopping area a boom and helped fellow merchants Melchoir Jewelers, Weinreich Hardware, and Wagner the tailor. Jack Weinstein—born at the Mount Sinai Hospital to Morris and Anna and named for his uncle Jack Levin—recalled the victory garden in the back of the store, which produced radishes for Passover in 1943. That year, the horseradish was so pungent that Anna cried for several minutes after grinding it for the Seder. The family moved again, in 1952, to Northeast Philadelphia. (Courtesy of Jack Weinstein.)

Carl Grunfeld settled in West Philadelphia after leaving Hungary in the second decade of the 20th century. He opened Grunfeld's shoes at 1210 North Fifty-second Street and Girard Avenue. Carl's son Joseph, a 1929 graduate of Overbrook High School, came into the business in the early 1940s and rebuilt the magnificent facade of the store with attention to thick plate glass and marble panels. He also used the traditional black-and-white checkered tile with the name of the business in the entranceway. In 1946, the Grunfelds migrated to the Wynnefield section, two blocks from the loop terminal of the No. 70 trolley that ran past the store. (Courtesy of David Grunfeld.)

Herman Boodis, a Russian immigrant, migrated from South Philadelphia to Overbrook in the far northwest reaches of West Philadelphia in 1919. Herman and his wife, Ida, raised their two children, Irv (pictured *c*. 1922) and Sylvia, in a predominately Italian-Catholic neighborhood at Sixty-fifth Street and Lebanon Avenue, near the terminal of the No. 10 trolley car. Herman bought toy and novelty supplies from the Ponnock toy distributors downtown at Fifth and Market Streets. The Boodis family, well respected by its non-Jewish customers, *kashered* (made ritually pure with extremely hot water) their silverware in the soil behind the business prior to each Passover. They attended the West Philadelphia Jewish Community Center synagogue at Sixty-third Street below Market Street, often walking the eight-block distance even though they had an automobile. (Courtesy of Sylvia Boodis.)

Bill Leibowitz learned a vocation that would last a lifetime—cutting kosher meat, which he has done for more than 65 years. As young man, Bill migrated with his father, Sam, and mother, Ann Bell, from Germantown to Parkside, near Fifty-second Street and Columbia Avenue. Bill's siblings Herman, Ruben, Jacob, Morris, Bernard, and Sarah enjoyed the park setting off Parkside Avenue. At the age of 16, Bill went to work delivering kosher meat parcels on a bicycle to neighbors. He worked from the store that he would later own at 1715 North Fifty-second Street. Bill became an official in the Kosher Butchers Association, which boasted 500 members at its peak, in 1948. (Courtesy of Bill Leibowitz.)

Eight

NEIGHBORHOOD
SYNAGOGUES

The residential area in Philadelphia west of the Schuylkill River represented a large part of the city, with more than 25 percent of its neighborhoods. The geography of the communities and its landscape led to the creation of distinctive sections. The collective nature of the Jewish community, with its seven main areas of congregation, gave way to the development of its most central institution—the synagogue. Due to the topography of the land in West Philadelphia, Jewish neighborhoods or sections could support more than one synagogue in its boundaries. Early synagogues, built after the establishment of a quorum, were orthodox. The advancement in American Judaism and its creation of a centrist movement had its roots in Philadelphia, and conservative Judaism developed with a strong base throughout West Philadelphia with the creation of the United Synagogues of America. The influence of conservative Judaism, the third major movement, sprang from its rabbinical and lay leaders in Philadelphia, especially West Philadelphia Jewish neighborhoods that came into existence in the 1920s.

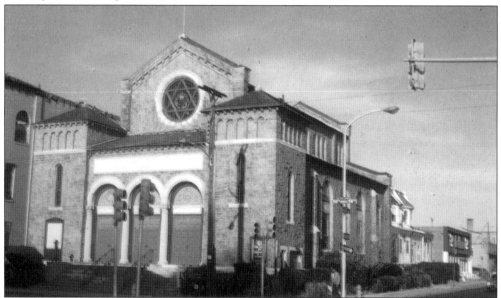

Beth El synagogue, at Fifty-eighth and Walnut Streets, began in 1904 as Jews from South and North Philadelphia migrated across the Schuylkill River into West Philadelphia. Rabbis Sam Freedman and Sam Lang led the community, which supported the largest Hebrew school, the Rothchild School, which had more than 1,000 students for over five decades. The largest edifice in the area, it seated 2,000 people, and included a choir and an organ for use on holidays. Beth El leaders were one of 13 congregations in America that supported the founding of United Synagogue of America in 1913—an association of conservative congregations. Beth El left the area in the 1960s. It now has congregations in the western suburb of Broomall and the Main Line suburb of Wynnewood.

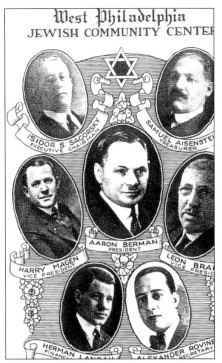

The West Philadelphia Jewish Community Center (WPJCC) synagogue, formed in the early 1920s, resembled other synagogue centers designed with space for athletic in addition to social and religious programs. The center, at Sixty-third below Market Street, was designed by Edwin Silverman and Andrew Sauer and was erected in 1926 at a cost of $300,000. This far exceeded the cost of any other West Philadelphia synagogue built in the community at that time. South Philadelphia native Rabbi C. David Matt, who was sent to the congregation by Chief Rabbi B.L. Levinthal, led the new WPJCC for one generation until his death in 1951. The large conservative synagogue attracted members primarily from the area north of Market Street. (Courtesy of Harry Geiger.)

Congregation Lenas Ha Zedek was organized in 1916 by Nathan Folstein, a Russian immigrant who originally settled in South Philadelphia. The *minyan* formed just as new homes were built along the new No. 46 trolley car line that ran on Sixtieth Street. Rabbi Leon Elmaleh of Congregation Mikveh Israel organized the Philadelphia board of rabbis, lived on Sixtieth Street, and assisted the new congregation until Rabbi David Swiren was called from Wilmington, Delaware, in 1921. Jack Fieldstein designed the new synagogue, erected at 5944 Larchwood Avenue. The congregation abided by orthodox traditions and provided leadership for its youth with dances in its social hall every Wednesday night. Rabbi David Wachfogel and Rabbi Morris Shoulson followed until the congregation closed its doors in 1964, as its membership migrated to new neighborhoods.

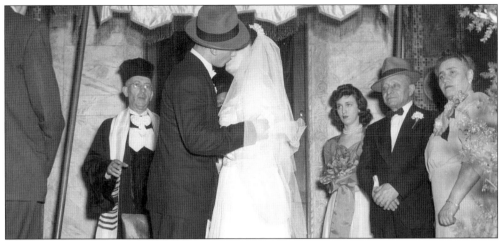

Weddings at the West Philadelphia Jewish Community Center were weekly rituals after World War II. Phil Greenstein and Estelle Cooperstein were married at the center in 1946. A large reception followed the ceremony, conducted by Rabbi C. David Matt with brother Jack Cooperstein, a former boy cantor, and Jake Cutler in attendance as witnesses. (Courtesy of Estelle Cooperstein Greenstein.)

Beth Hamedrash Hagodol, at 6018 Larchwood Avenue, was organized by Otto Preminger in the early 1930s over a schism over the Hebrew school curriculum at the nearby Lenas Ha Zedek *shul* at Fifty-ninth Street and Larchwood Avenue. Rabbi Meyer Cohen led the congregation with a mixture of old-world traditions and new conservative ideals by initiating confirmation classes. Norman Braiman, former owner of the Philadelphia Eagles, was one of its first confirmants. When the neighborhood changed in the 1960s, Rabbi Cohen migrated to Overbrook Park and created a new congregation. The Larchwood Avenue synagogue waned in the 1970s but remained open while nearby synagogues merged with it. In the early 1980s, David Nyman, Max Emas, Reba Fogel, Leon Greenstein, Adam Garfinkle, and Rabbi Chaim Budnick joined forces with the Jewish student body at the University of Pennsylvania to keep the synagogue open for members still living in the surrounding side streets to say *Kaddish* (prayers for deceased relatives) until 1990, when it closed its doors.

Left: The Jewish student population at the University of Pennsylvania organized the Menorah Society on campus in 1911. Dr. Cyrus Adler of Dropsie College selected Thirty-sixth and Locust Streets as the first site of what later became known as the Louis Marshall House for social activities in conjunction with the United Synagogue of America youth program. Jewish identity on campus was further advanced after World War II with funding from the Allied Jewish Appeal and the B'nai Brith Council to form the current Hillel House, which moved into its new home on Thirty-sixth Street between Walnut and Locust Streets in 1948. *Right:* Beth Emeth was organized in 1910 by merchants and was located at 4900–5300 Woodland Avenue. David Cook, a neighborhood kosher butcher, led the services and held the title of *shamus* and ritual director. The congregation erected its synagogue at 5217 Woodland Avenue in 1926. Beth Emeth closed its doors in the 1960s.

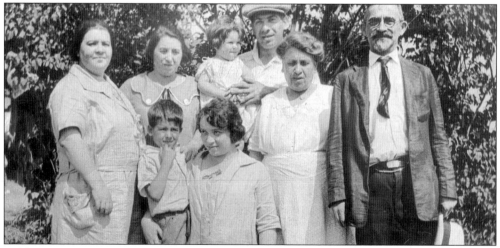

Rabbi Simon Sherman from Riga, Latvia, and his wife, Bessie, led the Beth Tefiliath Israel congregation, organized in 1920 at Thirty-ninth Street and Powelton Avenue. Joseph Stein married Leah Sherman, the daughter of Rabbi Sherman. The whole family joined in a picnic to raise funds for the synagogue in 1922, with Jack Stein, Anna Sherman Harris, and Fannie Sherman Eaton in attendance. Abe Sherman took the photograph. The synagogue served the merchants at Fortieth and Market Streets. (Courtesy of Sylvia Stein.)

The Moskow extended family, led by patriarch Moishe and matriarch Lebbeh, celebrated the wedding of Eddie and Rosalie Moskow with Mutzy, Bernie, Martin, and cousins Itsy and Ralph Kaplan in 1948 at the West Philadelphia Talmud Torah *shul* on Larchwood Avenue, west of Sixtieth Street. The synagogue started in 1919 as a school and later erected its multipurpose building with a large social hall doubling as a gymnasium. (Courtesy of Martin Moskow.)

West Philadelphia Jewry spilled over into the contiguous western suburbs of Delaware County as early as the second decade of the 20th century. The Darby Congregation, Agudas Achim, was organized with the help the Jewish merchants who conducted business on Main Street, the extension of Woodland Avenue. The Upper Darby Congregation Temple Israel served the Jewish merchants and residences in the Sixty-ninth Street shopping district at the Market Street El train terminal and trolley hub. The dedication of the Yeadon Jewish Community Center in 1949 took place with the rabbinical community of West Philadelphia in attendance. This program is a snapshot of the times, using pride in being Jewish, patriotic overtones of American ideals, and the jubilation over the new state of Israel to celebrate the new suburban *shul*. (Courtesy of Carl Goldberg.)

Honored Guests

Rabbi David A. Cardozo, *Rabbi*, Mikveh Israel Synagogue

Dr. Morris S. Goodblatt, *Rabbi*, Beth Am Synagogue

Harry Goss, *President*, Darby Synagogue

Rabbi Meyer Kramer, *Rabbi*, Congregation Brith Sholom

Louis Laver, *President*, Brith Sholom Synagogue

Dr. H. Levine, *Director*, Board of Jewish Education

Rev. Lawrence E. Manross, *Minister*, Germantown Christ Bible Church, Philadelphia

Louis Marion, Esq., *President*, Beth Am Synagogue

Rabbi Morris Newhoff, *Rabbi*, Darby Synagogue

Rabbi Louis Parris, *Rabbi*, Young Men's and Women's Hebrew Association of Philadelphia

Max Slepin, *Past Commander*, Pennsylvania Jewish War Veterans

Rabbi Edward Tenenbaum, *Rabbi*, Upper Darby Synagogue Center

Rev. Robt. M. Tignor, *Minister*, Yeadon Presbyterian Church

Rev. Martin L. Tozer, *Minister*, Yeadon Trinity Lutheran Church

Dr. R. G. Wallick, *Superintendent*, Yeadon Board of Education

Rev. Albert Witwer, Jr., *Minister*, Siloam Methodist Church

Benjamin M. Zieve, *President*, Upper Darby Synagogue Center

Shomrim is the Jewish fraternal organization of the Philadelphia police and firemen formed in 1937 to aid the growing number of Jews as uniformed public servants. During the Great Depression, a significant number of Jews took jobs on the police force in order to feed their families. The officers and their families socialized and fought anti-Semitism during the rise of Nazi Germany. The men in blue came together under their longtime chaplain, Rabbi Pinchas Chasin, at his synagogue, Beth Judah, on Fifty-fourth Street to celebrate the 10th anniversary of Shomrim in 1947. The 18th police precinct, located nearby at Fifty-fifth and Pines Streets, served this community. (Courtesy of Capt. Allen Kurtz and Capt. Arthur Gravitz.)

The 1940s were celebrated by social events before the advent of television. These events usually took place in living rooms of girls who invited male and female friends over for enjoying good Jewish *noshes*, such as hot, homemade potato knishes. Sam Hoffman (of blessed memory) and friends Irv and Ed Levin formed a chapter of the Young People's League (YPL) in 1939 at Congregation Beth Judah synagogue at Fifty-fourth and Samson Streets. Newly arrived Rabbi Pinchas Chasin performed marriages for many future Jewish couples that met in this matchmaking encounter, including that of Sam and Selma Hoffman. (Courtesy of Selma Hoffman.)

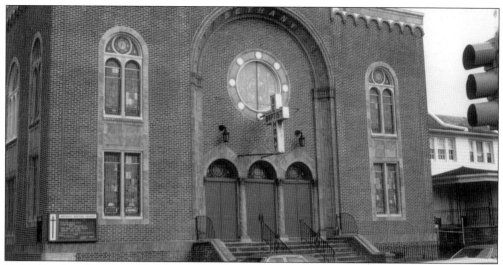

Beth Am Israel, a first- and second-generation congregation founded in the 1920s by the children of orthodox parents, erected its edifice on the northeast corner of Fifty-Eighth Street and Warrington Avenue in Southwest Philadelphia. The synagogue took great pride in becoming an American *shul* where prayers were recited in both Hebrew and English and men and women sat together. Rabbi Morris Goodblatt served the community for more than five decades and directly headed its large Hebrew school, which peaked with 800 students in 1958. In the 1960s, Rabbi Goodblatt appealed to the community at large to remain in the neighborhood as it was experiencing demographic changes. Finally, after a 10-year fight to remain a vital part of the community, the synagogue relocated to the Penn Valley section of Lower Merion Township, and the building was sold to a Baptist church.

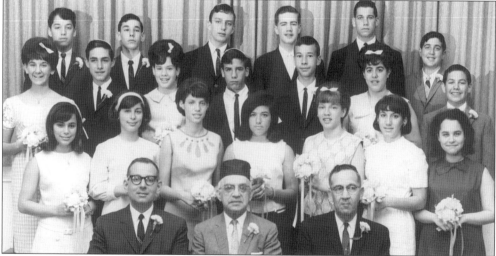

Beth Am Israel developed a reputation as a leading Jewish educational institution. Goodblatt, a graduate of the Jewish Theological Seminary in New York City, surrounded himself with capable leaders such as Sidney Lictenstein and developed one-time students into important lay leaders, such as Edward Kornblatt. He is known by hundreds of adults as the father of the *shtetl* in his role as principle of the Hebrew school. Kornblatt inspired the children who received his love and affection. His goal of making "happy and convinced Jews" with an understanding of Judaism was a main priority of his teaching. (Courtesy of Edward Kornblatt.)

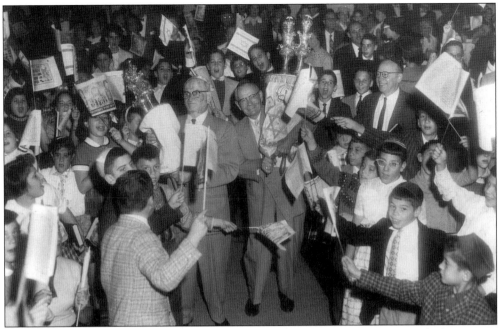

Dancing in the busy wide thoroughfare of Warrington Avenue with many Torahs became an annual ritual started by Rabbi Morris Goodblatt at Beth Am Israel upon his arrival in Philadelphia in the mid-1920s. The tradition continued well into the 1950s with Phillip Holtz and Samuel Pariser, who led this joyous occasion in 1958. The small-town culture of Southwest Philadelphia led to a complete sense of safety and security such that an outdoor festival featured Judaism's most precious possessions, the Torah scrolls. This is the Jewish holiday of Simchas Torah, or "rejoicing of the law." (Courtesy of the Philadelphia Jewish Exponent and Steve Feldman.)

 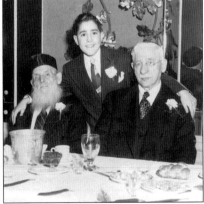

Left: Ellen Kaplan (from 5827 Warrington Avenue) met her future husband, Barry Savitz, at Congregation Beth Am Israel through the many social activities held at the synagogue, sponsored by the United Synagogue youth organization. Joining the couple in their wedding celebration were Percy and Sara Savitz, Jackie and Zell Savitz with their two children, Marcy and Jill, and brother Ephraim and his wife, Harriet. (Courtesy of Barry and Ellen Savitz.) *Right*: In 1949, Rabbi Goodblatt personally taught Carl Goldberg to recite his Torah portion and give his bar mitzvah speech. The joyous *simcha* was witnessed by both of his grandfathers, Morris Rudnick and Morris Goldberg. (Courtesy of Carl Goldberg.)

Left: The Jewish community of Island Road in Southwest Philadelphia supported three synagogues. Agudas Achim was in the semi-rural section of Eastwick near the Philadelphia airport. It was organized in 1910. The new Talmud Torah Hebrew school was founded in 1908 at 3012 South Eightieth Street at Harley Avenue. Another synagogue, Emunas Israel at 7828 Brewster Street, was founded by the elder Sam Gottensegen and his wife, Rebecca, who were farmers. (Courtesy of Abe and Louis Levin.) *Right:* The rare photograph of the Atereth Israel synagogue at 3119 South Eighty-fourth Street at Harley Avenue is a tribute the Jewish Farmer's Congregation, as it was originally known. The synagogue flourished from the 1890s until the 1950s but closed with the Philadelphia redevelopment authority master plan to rebuild the Eastwick area The children of the Island Road community and their grandchildren returned years later and held annual picnics and luncheons to reminisce. (Courtesy of Abe and Louis Levin.)

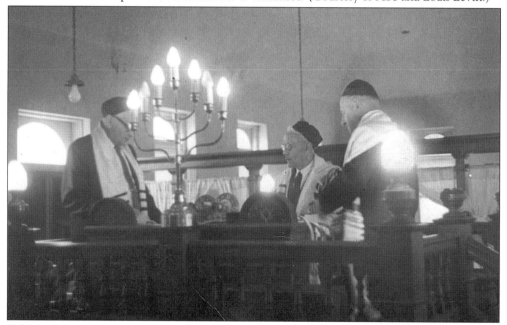

Taking photographs inside an orthodox synagogue during the Sabbath or Jewish holidays is strictly prohibited by Jewish law, as it violates the sanctity of the day. In the late 1950s, as Congregation Atereth Israel came to end, the members of the Eighty-fourth Street *shul* wanted to validate their existence. Pictured here are the last leaders of the congregation, Paul Cohen, Abe Levin, and Hymie Kotzen. These men opened the building on Mondays and Thursdays according to Jewish Law to read scripture from the Torah scroll. (Courtesy of Ben Cohen.)

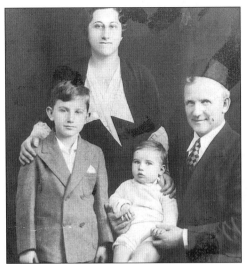

Left: Rabbi Elias Beller came as an immigrant from Russia to America before World War I and settled in the Island Road community with his wife, the former Florence Greeman, and children, Edwin and Joseph. Beller was a banker and Talmudical student who was persuaded by Chief Rabbi Bernard Leventhal to shepherd the Jews of Island Road from 1920 until 1946. The Bellers migrated to Wynnefield after World War II. (Courtesy of Joseph Beller.) *Right:* The residents of the Meadows formed the social and benevolent Ladies Aid Society to welcome new immigrants in the early 1900s. Rose Yaskin, Esther Kotzen, Ida Chabad, and Rose Weber led this group of women to aid and comfort residents to Island Road to weather the Great Depression. (Courtesy of Ben Cohen.)

Paul Cohen, the unofficial leader of the Eightieth Street *shul* Agudas Achim, performed many rituals for the individual members of the community. The ceremony of *Pidyon ha-ben,* or redemption of the first-born male child, was observed 30 days after birth. This ceremony released the boy from service to the priests in the old Temple in Jerusalem during biblical days. Mr. Schwartz, who owned a drugstore on Eastwick Avenue, is in attendance and reverently covered his head with a napkin as he participated with his child in the ceremony in the late 1940s. (Courtesy of Ben Cohen.)

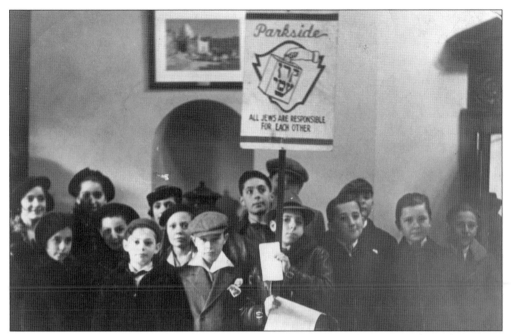

Tikvas Israel synagogue at Forty-first and Viola Streets was founded in 1920 by a study group of men who met in an old hotel on the same site. The outcry of a homeland for the Jewish people, heard throughout the community from the end of World War I, included activities of the Hebrew school, which supported the Jewish National Fund with its fundraisers through the familiar blue and white collection boxes. Mr. Karpf and Morris Volinsky taught Len Barkan, Eddie Zimmerman, Marty Sklaroff, Herb Krachowitz, Albert Berman, Stan Reedman, and Morris Chester their lessons. (Courtesy of Len Barkan.)

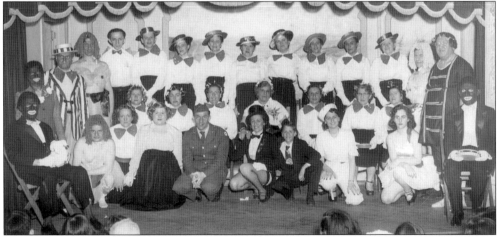

Shirley and Max Weinstein married in 1932 and migrated to Fortieth Street and Girard Avenue. The couple decided to join Congregation Tikvas Israel over Congregation Tifereth Israel, located at Girard below Fortieth Street. The synagogue allowed women and men to sit on the ground level, with men on the right and ladies on the left. Tikvas Israel offered more social activities, such as shows put on by both men and women The popular minstrel show put on by the congregation helped to raise funds for the synagogue annually. (Courtesy of Cecelia Weinstein Rothmel.)

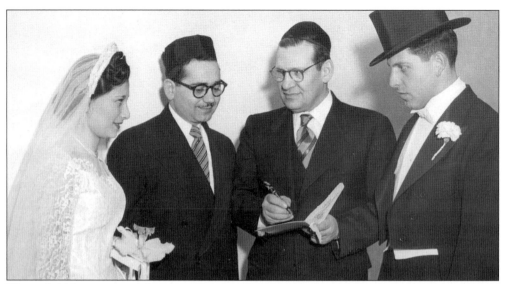

Wynnefield Jews interacted with each other on many levels, including educational, religious, and social. Jewish people traditionally married others from the same community in Europe, and that applied here in America. Gary Rothmel (from 5327 Montgomery Avenue) and Cecelia Weinstein (from 5340 Arlington Street) were introduced by mutual friends and were married on January 17, 1954. The Rothmels' wedding ceremony—with Rabbi Morris Schnall of Shaare Zedek, at Fifty-second and Columbia Avenue, and Rabbi Harry Foreman of B'nai Israel, at Fifty-third and Euclid Avenue in Wynnefield—took place as the inaugural wedding reception at the Wynne Caterers on North Fifty-fourth Street. (Courtesy of Gary and Cecelia Rothmel)

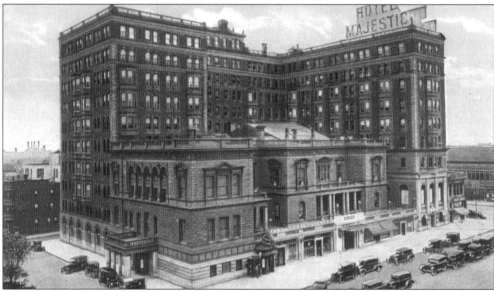

Prior to the design of the large synagogues with Hebrew schools and social halls, Jewish couples were traditionally married in the bride's home. During the 1920s, a new tradition began, with wedding receptions held at large hotels with kosher kitchens. The Majestic Hotel, on north Broad Street and Girard Avenue, hosted many weddings throughout the 1930s and 1940s. Architect Joseph Huston designed the Majestic Hotel, which was built around the core of the old Elkins mansion in 1902. (Courtesy of the Bob Skaler collection.)

Har Zion Temple of Wynnefield, at North Fifty-fourth Street and Wynnefield Avenue, was founded in 1922. It grew in stature throughout the community and became the leading congregation west of the Schuylkill River. For more than five decades, this strong conservative synagogue had only three rabbis—Simon Greenberg, David Goldstein, and Gerald Volpe. The synagogue became a center for pro-Zionist activities and supported a strong Israel Bond drive, a well-staffed Hebrew school, a home for the Solomon Schector day school, Akiba Academy (a Jewish secular secondary school), Camp Ramah in the Pocono Mountains, and a vibrant United Synagogue Youth (USY) group. Neighborhood change forced the congregation to relocate to the Penn Valley section of Lower Merion Township in the late 1970s.

Building for the future was a continuous theme at Har Zion Temple. Greenberg, Goldstein, and Volpe, along with countless lay leaders, made the migration of Har Zion to its present site in Penn Valley a reality in 1974. (Courtesy of the archives at Har Zion and Sandy Siegal.)

"Like father, like son." Jewish life in Philadelphia is full of dramatic stories where children follow in their parents' footsteps, in business and professional careers. The old-world tradition of a chain of rabbis linking one generation to another was carried over to America with the arrival of the east European rabbis, especially in the 1920s. David Novoseller's family included several boys. Sherman and Maurice both became rabbis in accordance with family tradition. Beth Tovim converted a former mansion at Fifty-ninth Street and Drexel Road into a synagogue, with Sherman Novoseller as its rabbi. The *shul* is still in existence, named for a kind contributor, whose Hebrew name was Tuvia.

Congregation B'nai Joshua started as a prayer *minyan* at 5300 Morse Street during the late 1920s in the Wynnefield section. During the Great Depression, Chief Rabbi Bernard Levinthal sent Rabbi Novoseller to the area in hopes of bolstering the Wynnefield Jewish community, which numbered 1,000 families. Rabbi Novoseller, a strictly orthodox rabbi, supervised the kosher catering and Jewish bakeries in Philadelphia. One could often see his signature approval in addition to *KP* (kosher for Passover) on the bottle caps of Frank's soda water. The congregation built its *shul* after World War II at 5343 Berk Street.

Rose and Chaim Harris migrated from South Philadelphia to Strawberry Mansion and Logan, finally settling and opening a drugstore at Fifty-sixth and Diamond Streets in Wynnefield. The couple, who spoke only Hebrew, had four children—Shoshana, Tsvi, Anyla, and Zelig—and opened their house at 2222 North Fifty-third Street in 1950 to share their love of Judaism. Chaim, a cantor at Congregation Tikvas Israel, in the Parkside section, became a *mohel*. The Yavne *shul*, one of 22 synagogues in Wynnefield, sponsored Hadassah and Jewish National Fund meetings to support the new state of Israel. (Courtesy of Shoshana Harris Sankowsky.)

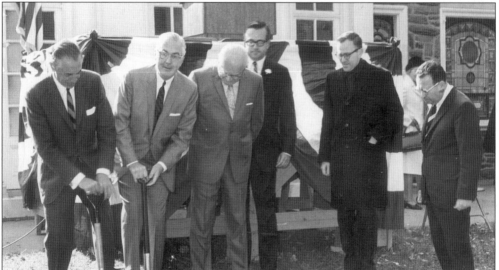

The Beth David reform congregation at Fifty-third Street and Wynnefield Avenue completed a unique piece of Jewish Americana real estate. Nowhere else in America existed three city blocks filled with three synagogues that depicted the three major movements of Judaism. Beth David shared this honor with orthodox congregation Young Israel of Wynnefield and conservative congregation Har Zion Temple. Beth David was founded as the first reform congregation in Philadelphia with an east European base in 1942. It expanded its facilities in 1967; city dignitaries are shown in attendance with Rabbi Henry Cohen looking on. Beth David yielded to neighborhood change in the 1990s and relocated to the Gladwynne section of Lower Merion Township. (Courtesy of the Jewish Exponent and Steve Feldman.)

The role of women in Judaism is well defined throughout Jewish history. Participation in the daily and weekly rituals did not occur until the residual effect of Jews living in America took firm hold after the women's suffrage act of 1920. The bas mitzvah ceremony for girls—created in 1924 by visionary Rabbi Mordechai Kaplan, founder of the Reconstructionist movement in America, for his own daughter—provided Ariel Wilson, daughter of Arthur and Janice, an opportunity to express her knowledge of Hebrew and her commitment to Jewish life. This ceremony took place at Congregation T'fillah Israel in Overbrook Park, when she celebrated her 13th birthday in 1994. (Courtesy of Janice Wilson.)

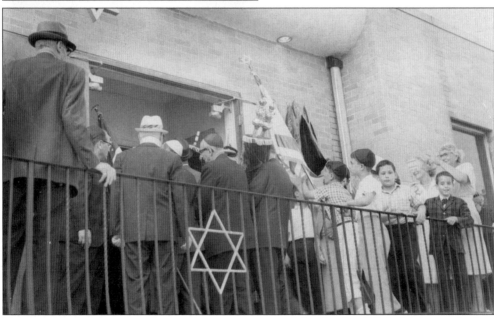

New neighborhoods sprouted up in the open spaces and farmlands of Philadelphia in the late 1940s. Overbrook Park came into existence as new housing for returning GIs and their growing families. Rabbi Meyer Cohen, formerly from Beth Hamedrash Hagodol at Sixtieth Street and Larchwood Avenue, migrated out of West Philadelphia and founded Beth Hamedrash of Overbrook Park, an orthodox congregation. The congregation hosted a large community festival to welcome the Torah scrolls into its new synagogue on the 7500 block of Brookhaven Road in the late 1950s. (Courtesy of Lee and Susan-Moskow Photography Studio.)

Nine

WORLD WAR II HEROES

Jewish Americans came to the aid of their country from the outset of World War II in great numbers, many hailing from West Philadelphia. Jews joined their neighbors in the war effort, realizing that they might have to lay down their lives for the freedom their country gave them. The pride of the Jewish families was displayed in many front porch windows throughout the community with large, felt, blue stars for each son serving in the military, or a gold star for each family member killed in action. The Jewish community of West Philadelphia boasted of their patriotism and contributions to America with the formation of several American Jewish War Veterans posts at the end of World War II.

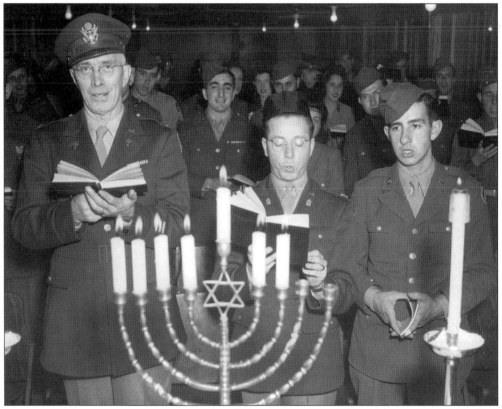

Jews served their country in all major wars dating back to Revolutionary times. Rabbi Pinchas Chasin, a native of Chicago, Illinois, arrived in Philadelphia in 1939 to serve the West Philadelphia congregation Beth Judah at Fifty-fourth and Samson Streets. Tradition and service to one's country were inseparable for Pinchas, who enlisted in the U.S. Army as a chaplain only months after meeting and marrying Bea Pugatsky. The couple has three children—Rena, Meryl, and Daniel. Rabbi Chasin continued to serve his adopted community for the next 55 years, serving only Beth Judah and Temple Sholom, in Northeast Philadelphia's Oxford Circle section. (Courtesy of Rabbi Pinchas Chasin.)

Arlington Street native Ronnie Forman from Wynnefield joined the U.S. Army in 1944 right out of high school. Proud to serve his country and fight overseas, Ronnie survived and, after arriving home, started an aluminum screen door company and later patented the "bomb bat," an aluminum-core baseball bat. (Courtesy of his friend Len Barkan.)

N⁰ 679372CH UNITED STATES OF AMERICA
OFFICE OF PRICE ADMINISTRATION

WAR RATION BOOK TWO

THIS BOOK NOT VALID

IDENTIFICATION

Barson Alan Howard
(Name of person to whom book is issued)

602 South 60 Street
(Street number or rural route)

PHILADA. PENNA. 5 M
(City or post office) (State) (Age) (Sex)

AUX. BD. 8 PHILA.

ISSUED BY LOCAL BOARD No. _____
(County) (State)

(Street address of local board) (City)

By _Dorothy Ide_
(Signature of issuing officer)

SIGNATURE _Alan Howard Barson (mother)_

(To be signed by the person to whom this book is issued. If such person is unable to sign because of age or incapacity, another may sign in his behalf)

WARNING

1 This book is the property of the United States Government. It is unlawful to sell or give it to any other person or to use it or permit anyone else to use it, except to obtain rationed goods for the person to whom it was issued.

2 This book must be returned to the War Price and Rationing Board which issued it, if the person to whom it was issued is inducted into the armed services of the United States, or leaves the country for more than 30 days, or dies. The address of the Board appears above.

3 A person who finds a lost War Ration Book must return it to the War Price and Rationing Board which issued it.

4 PERSONS WHO VIOLATE RATIONING REGULATIONS ARE SUBJECT TO $10,000 FINE OR IMPRISONMENT, OR BOTH.

World War II created shortages of basic food provisions, such as sugar, flour, and meat. Ration stamp books were issued to all family members, regardless of age, to limit what they could buy within a month. When supplies at stores ran out, the stamps left in the books were useless. Even merchants were required to have these books. The fascinating part of the ration book's history can be found on the last page of this government document, which states, "Do not throw away this book even when the stamps have been used." Many citizens held onto to these reminders of World War II for years. (Courtesy of Alan Barson.)

Left: Bernie Stern, the son of shoemaker Abe and Minnie, lived at 418 South Fifty-fifth and Pine Streets. He grew up with a deep appreciation of family, religion, and belief in Judaism that would carry him throughout his life. The Stern children, Harry, Clarence, Eddie, and Dorothy, watched their mother help all people in the community through the West Philadelphia Refreshment Circle. Bernie met his future wife, Fay, in 1946 at a USO dance at the Broad and Pine Street YMHA canteen while on military leave. (Courtesy of Ira Stern.) *Right:* David Guralnik (from 3821 Poplar Street) was the son of Russian immigrant parents—Jacob, a vest maker, and Rose. David enlisted in 1943 and served in the 142nd Ordnance Battalion, fighting in North Africa, Europe, Philippines, and Japan. After the war, he took a job greeting returning soldiers and informing them about their entitlements. (Courtesy of Dave Guralnik.)

NATIONAL JEWISH WELFARE BOARD

MEMBER OF UNITED SERVICE ORGANIZATIONS

USO

This certificate is awarded to

FRANCES COHEN

in recognition of distinguished service to the men

and women in the Armed Forces of the

United States of America through the

Army and Navy Activities of the

National Jewish Welfare Board

World War II

Jewish women served their country with pride and valor on the home front in Philadelphia during World War II. Frances Cohen, from the Meadows, traveled on the No. 37 trolley car to the YMHA at Broad and Pine Streets daily to assist in activities for Jewish soldiers as an employee of the Jewish Welfare Board. (Courtesy of Frances Cohen Weiss.)

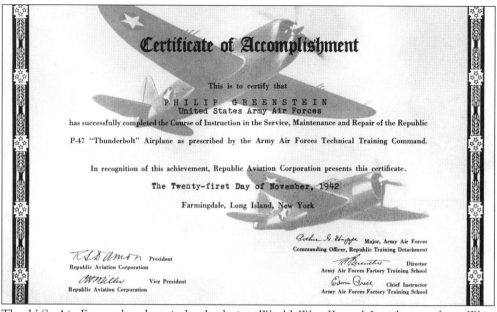

Certificate of Accomplishment

This is to certify that

PHILIP GREENSTEIN
United States Army Air Forces

has successfully completed the Course of Instruction in the Service, Maintenance and Repair of the Republic

P-47 "Thunderbolt" Airplane as prescribed by the Army Air Forces Technical Training Command.

In recognition of this achievement, Republic Aviation Corporation presents this certificate.

The Twenty-first Day of November, 1942

Farmingdale, Long Island, New York

Arthur G. Hoppe Major, Army Air Forces
Commanding Officer, Republic Training Detachment

R. S. Damon President
Republic Aviation Corporation

R. Brunette Director
Army Air Forces Factory Training School

W. Miller Vice President
Republic Aviation Corporation

Edwin Brief Chief Instructor
Army Air Forces Factory Training School

The U.S. Air Force played a vital role during World War II, and Jewish men from West Philadelphia qualified as various personnel in America's fight for freedom on several fronts. Phillip Greenstein passed the course on maintenance of the P-47 Thunderbolt fighter plane in November 1942. (Courtesy of Estelle Cooperstein Greenstein.)

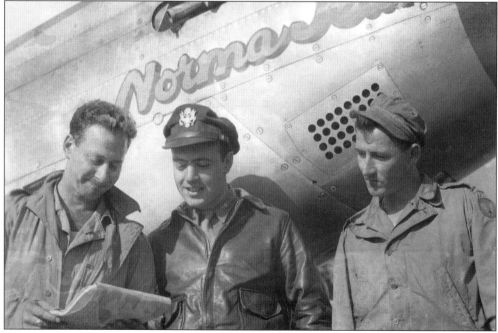

Greenstein proudly poses with his air force colleagues as they look over reports of flight plans. He had a great sense of humor that calmed many pilots before they took off for bombing runs over Germany. The airplanes were often named for the sweethearts of the pilots. After the war, Greenstein went to work for the Ponnock Toy Company and later opened the famous Phil's Luncheonette. (Courtesy of Estellle Cooperstein Greenstein.)

Left: Jews from Island Road served their country with vigor and valor. Coast Guard member Moe Ruttenberg (left) and Heshie Friedman (the grandson of Aaron Caplan, the owner the Island Road bottling company on Eighty-fourth Street) enjoy each other's company for a short time before shipping out in 1945. (Courtesy of Heshie Friedman.) *Right:* Aaron and his brother Rubin Kuptsow both served in the U.S. Air Force during World War II. The reunion of the siblings gave hope to their mother. (Courtesy of Aaron Kuptsow.)

Aaron Kuptsow, originally a South Philadelphia boy, migrated to West Philadelphia at Fifty-fifth and Spruce Streets before enlisting in the eighth division of the U. S. Air Force as a radar navigation bombardier. He was shot down with the rest of his crew in a B-17 bomber and was taken prisoner in Germany for six months until liberated by the Russian army. (Courtesy of Aaron Kuptsow.)

Left: Boyhood friends from West Philadelphia were separated by the outbreak of World War I. Ed Lewis (6200 Hazel Street) and Irv Hoffman (246 South Ithan Street) were last seen together before Irv Lewis lost his life on the sinking of the warship *Dorchester.* In addition, the famous four chaplains went down with the ship. (Courtesy of Selma Hoffman.) *Right:* Eli Cotler, from Forty-second and Stiles, joined the U.S. Navy and went overseas immediately after graduating Overbrook High School in 1944. Eli's father, a home builder, prayed each day for his son's safe return home. (Courtesy of Len Barkan.)

Coming home was a delight for Buddy Actman, who joined the service on the Shribe Park field at Twenty-first Street and Lehigh Avenue, home of the Philadelphia Athletics baseball team, along with about 1,000 other men. The men then walked to North Philadelphia Station and shipped out on military trains heading to New York. Neighbors Aaron and Florence Ogen came to 1722 Marlton Street near Fortieth Street and Girard Avenue to celebrate Buddy's short leave and homecoming with his parents, Kitty and Morris, in November 1942. (Courtesy of Bud Actman.)

DEDICATION
of
SERVICE FLAG

TO THE MEN

IN THE

ARMED FORCES OF OUR NATION

☆

SUNDAY, OCTOBER 4, 1942

39th and Pennsgrove Streets

2:00 P. M.

Program
☆

1. NATIONAL ANTHEM—"STAR SPANGLED BANNER"
2. INVOCATION Rabbi Gerson Brenner
3. UNFURLING OF FLAG Men in Service
4. INTRODUCTORY REMARKS Irving Achter
 Post Commander, Parkside Post, J.W.V. No 151
5. SPEAKER Isadore Buchbaum
 National Chief of Staff, J.V.W. of U.S.A.
6. VOCAL SELECTION Phillip Canar
7. SPEAKER Nathan Muchnick, B.S.
8. MUSICAL SELECTION Band
9. SPEAKER First Lieutenant Walter Burows
 Commanding Officer, Co. D, 722nd Military Police
10. SPEAKER Hon. James P. McGranery
11. SPEAKER Colonel Vincent A. Carroll
12. VOCAL SELECTION—GOD BLESS AMERICA ... Phillip Canar

Honor Roll
☆

DIAMOND, IRVING	HORWITZ, MOE
FISHMAN, JOSEPH	LOADENTHAL, SIDNEY
FRANTZ, DR.	SLUTSKY, BENJAMIN
FOLK, SIDNEY	ZWICKEL, JACOB
HOLDERMAN, SOL	BERG, SAMUEL
HOLDERMAN, LEON	DRESSLER, HARRY
HANKER, MAX	DRESSLER, JACK
ISACOWITZ, LEON	KAZMAN, BENJAMIN
KAPLAN, ISADORE	LARKIN, FRED
KAPLAN, MORRIS	RUTTENBERG, MORRIS
PINCUS, MAX	SHAPIRO, BENJAMIN
SHERMAN, VICTOR	SHAMES, IRVING
SAPOLSKY, BENJAMIN	WEBER, RUDOLPH
SCHWARTZ, JOSEPH	YABLON, MILTON
SHARP, NORMAN	FINGERHOOD, RAYMOND
SOLOMON, EDWARD	BOOKBINDER, SAMUEL
SOLTFAS, JOSEPH	RAINES, COLEMAN
WAX, HENRY	YUDOFF, MARTIN
WAX, MICHEAL	DENENBERG, PAUL
WEBER, AARON	OSTACH, MORRIS
WINEFSKY, FRANK	DAVIS, BENJAMIN
YOUNG, ALBERT	CHERRY, BENJAMIN
COHEN, MARTIN	BLUESTEIN, JACOB
DUTKIN, LEON	SACKS, FRED
FREEDMAN, MORTON	SACKS, HERMAN
KANEFSKY, RUDOLPH	

Patriotism took on many forms in the community around Fortieth Street and Girard Avenue. The Jewish War Veteran Post No. 151—located at Thirty-ninth and Pennsgrove Streets and headed by Irv Achter—rallied the neighborhood to pay tribute to Jewish men in the neighborhood who had paid the supreme price for freedom early in 1942. Popular West Philadelphia Rabbi Gershon Brenner officiated. (Courtesy of Sidney Fingerhood.)

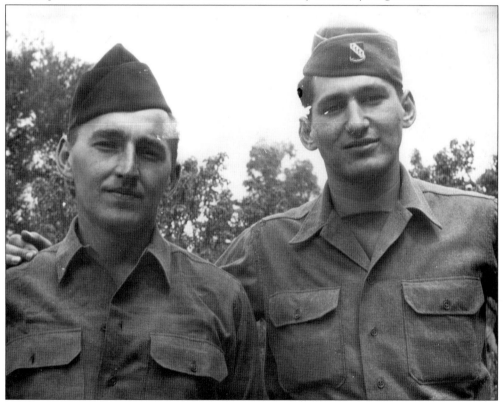

Belief in divinity is what kept the Actman brothers alive during World War II. Betram enlisted and his brother Aaron was drafted in the U.S. Army. The boys miraculously met up with each other in Italy as their combat units were engaged in heavy fighting with the enemy. The *Stars and Stripes* military newspaper carried the incredible story. (Courtesy of Bert Actman.)

Left: Jewish families communicated with each member and became stronger during World War II. Ida and Ben Cherry were married in 1920 and had four children: Moishe, Mendel, Sylvia, and Sarah. They are pictured during the Jewish holidays in 1943. Moishe, a photographer in the U.S. Marines, was killed while he participated in the Normandy landing in June 1944. (Courtesy of cousin Fran Cohen Weiss.) *Right:* Helen and Alex Magid celebrate a quite moment on big Webster (5900) Street in West Philadelphia with their young son Larry during the high holidays in 1944. Alex returned home from the war to assume his clothier job and became a Democratic committee member. (Courtesy of Larry Magid.)

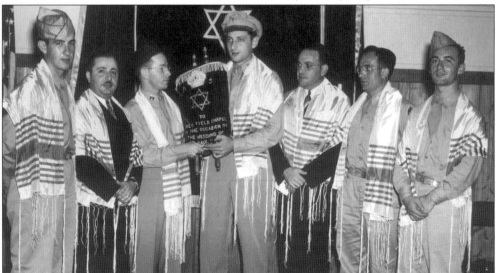

Religious services were routinely conducted during World War II by all Jewish denominations. Rabbi Pinchas Chasin, stationed in the southern United States, conducted Rosh Hashannah services for men and women separated by many miles away from home. (Courtesy of Rabbi Pinchas Chasin.)

Ten

BOYCHICKS AND MAVENS GROWN UP

Jewish boychicks (boys) and mavens (girls) experienced a whole world in West Philadelphia while on their way to adulthood. Their development was based on social, educational, religious, and family ties and made them what they are today. Everyone prospered by having a West Philadelphia background that prepared them for life. Very few adolescents think about the future in terms of who they will meet and marry or where they will reside later in life. West Philadelphia provided a great place to grow up, with everything needed right in one's own backyard. West Philadelphians were driven by their parents' ambitions to make better lives for themselves. This American value was successfully transferred to the next generation. These success stories mean so much and can not be calculated in dollars and cents.

Martin Moskow, son of Sarah and Ed, grew up at 5738 Hazel Street, close to everything in West Philadelphia in the 1950s. Friends made up his early life, including Simon Kaplan, Irv Zuber, Jerry May, Paul Leasoff, Lenny Barisloff (Barry), and Arnie Silver (Satin) of the singing group known as the Dovels. Movie stars and entertainers were plentiful in this neighborhood. Benny Kurland's father was a neighborhood kosher butcher on Sixtieth Street. Moskow's favorite hangout was Bob's tune shop, also on Sixtieth Street. Martin took the stage name of Marty Ross when he played Tevia in the classic hit *Fiddler on the Roof*, which ran for many years on Broadway in the 1980s. Martin now resides in Florida, where he is a cantorial soloist. (Courtesy of Martin Moskow.)

Max Leon loved making music come to life. An immigrant from Poland in the early 1900s, Max purchased the Wholesome Products Company in 1934. Max never lost touch with his musical inclinations and went from violin player to saxophone soloist and from Philadelphia Mummer to conducting the Philadelphia police and fireman's band. Famed conductor Eugene Ormandy was his teacher. Max then founded the Philadelphia Pop Orchestra, which launched many talented musicians and raised millions of dollars in World War II bond drives. Leon purchased radio station WDAS in 1950 and brought his son-in-law Bob Klein into the business. They boldly switched formats to rhythm and blues. The station's place in musical history was only outdone by its major role in the civil rights movement nationally and its award-winning news department. This great humanitarian lived in Wynnefield, held many Masonic titles, cut a ribbon on an internationally respected mosque, and aided many people affected by the 1960s flood of Florence. For this the Italian government knighted him for his philanthropy. (Courtesy of Sonia Leon.)

Sidney Kimmel, the son of a West Philadelphia taxi driver, grew up at Sixtieth and Samson Streets and attended Beth El synagogue at Fifty-eighth and Walnut Streets. After graduating West Philadelphia High School in 1945, Sidney attended Temple University and went to work at the Somerset Knitting Mills in North Philadelphia. Through hard work, Sidney Kimmel became the president of Jones Apparel group beginning in 1970. The clothing giant known originally as Jones New York is still headquartered in the Philadelphia region. The philanthropic contributions of this former West Philadelphian can be seen around the city; the new Kimmel Center for the Performing Arts is scheduled to open on the University of the Arts campus (Broad and Spruce Streets) in December 2001. (Courtesy of Sidney Kimmel.)

Everyone in Philadelphia knows the legendary Norman Braman, former owner of the Philadelphia Eagles football club. Brash and bold is the way most people know Norman through his business savvy, but did you know that he is a former West Philadelphian from 6239 Larchwood Street in the Cobbs Creek section of West Philadelphia? Norman was confirmed at the Beth Hamedrash Hagodol synagogue at 6018 Larchwood Avenue and later graduated West Philadelphia High School in 1950. Today, Norman owns an exclusive automobile agency in Miami, Florida. (Courtesy of Norman Braman.)

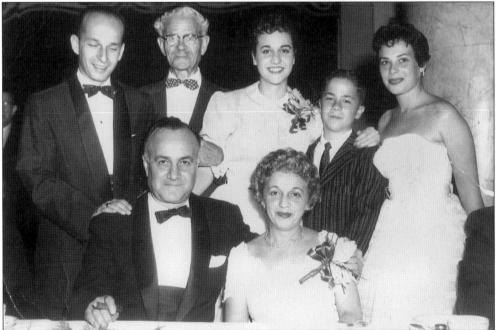

The Rubin Real Estate family had roots in West Philadelphia at various addresses, including 6043 and 6203 Catherine Street. The Rubin clan, pictured here, included Ron Rubin's grandfather Frank; his father, Richard, who started the business in 1946; George; Dorothy; and Marcia, Ron's wife. Ron broke into the business in 1952 at a time when his father was in the insurance, property management, and real estate business, with offices at 123 Sough Broad Street. Ron called his friends "the Catherine Street Irregulars." They included Marvin Rose, Dick August, Freddy Freedman, Gerald Rotwein, Sam Wiener, and Jules and Irv Pomerantz—all of whom went to the Bryant Elementary School. (Courtesy of Ron Rubin.)

Left: Sherman Frank came from Sixtieth and Washington Avenue and rose to fame in the field of music through hard work and attention to detail. Training at the Curtis Institute of Music under Rudolf Serkin led to his debut as a concert pianist in New York City. Later, Sherman turned to conducting dozens of shows on Broadway, operas, motion pictures, and television productions. (Courtesy of Sherman Frank.) *Right:* Some Jewish people changed their names when they broke into show business to hide their Jewish identity from the audience. Lillian Schectman, proud of her heritage, selected the stage name of Lillian Shelby to augment her showcase debut at the New York City Opera Company in 1969. Lillian, originally a Wynnefield girl, married Sherman Frank. (Courtesy of Lillian Shectman Sherman.)

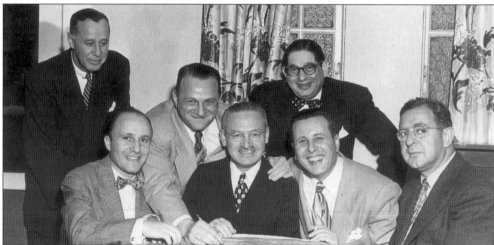

The Herb Yentis real estate business in West Philadelphia opened at its original location at Sixtieth and Market Streets in 1926. Other colleagues joined together to create their futures in the newly developing Overbrook Park section beyond West Philadelphia. Joseph Harris, president of West Philadelphia Federal Savings Bank, is joined by real estate brokers Mort Rubin, Rubin Petosky, Herb Yentis, and Nathan Sherr as they plan for a new branch of the West Philadelphia Federal Savings and Loan on the 7500 block of Haverford Avenue. George Goldstone married Jackie Yentis, the daughter of Herb. Goldstone joined the real estate business, which celebrates its 75th anniversary in 2001. (Courtesy of Jay and George Goldstone.)

Lynne Abraham, a longtime Philadelphia political figure, grew up in West Philadelphia at 5939 Addison Street near the Addison Jewish bakery. Stores in her neighborhood were so familiar, with names such as Zeke's grocery store, Dash's and Hymie's Delicatessens, Babis Pharmacy, Moskowitz's Bakery, and the Boston candy store. Today, Lynne Abraham is known as a "tough cookie" district attorney who prosecutes career criminals to the fullest extent of the law. (Lynne Abraham.)

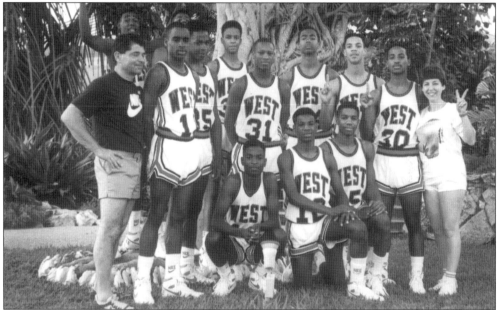

Playing basketball is a Jewish tradition in Philadelphia. The Jewish Basketball League and its alumni are proof that the sport was once the center of Jewish boys' lives. Joey Goldenberg lived at Fifty-fifth Street and Windsor Avenue in Southwest Philadelphia and attended West Philadelphia High School, where he defended the position of guard and played against the famed Walt Chamberlain from Overbrook High School in the 1950s. He later became a coach at the school, instilling respect amongst the members of his team. He took over the position from longtime coach Doug Connelly in 1969. One outstanding player that Joey coached, Gene Banks, made it to the National Basketball League in the 1980s. (Courtesy of Joey and Claire Goldenberg.)

Left: Life provides twists and turns for many of its travelers. Aaron Kuptsow knows that road only too well as a former prisoner in World War II. Upon arriving home, Aaron signed up for Temple's dental school, until his brother convinced him to become an osteopathic doctor. Aaron's friends, Lou Pertschuk and Sam Rubin Stein, pose for a farewell photograph from the Osteopathic School of Medicine at Forty-eighth and Spruce Streets, West Philadelphia, in 1950. (Courtesy of Aaron Kuptsow.) *Right:* Jewish women from West Philadelphia played a critical role in the development and financing of the new State of Israel, created in 1948. Mae (Manya) Abramson, who lived at 1612 South Fifty-seventh Street, was an active member of Beth Am Israel synagogue, Hadassah, and Pioneer Women. She felt it her duty as a third-generation Zionist to sail to Israel. The journey in 1963 held special meaning to Manya, who established a memorial in Kfar Achim for her parents, who perished in the Holocaust. (Courtesy of Bettyanne Gray.)

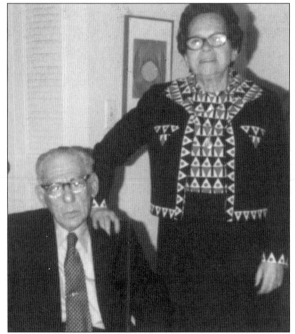

West Philadelphia, large enough to qualify as a city, provided ample opportunity for residents to live and work in the same community. This couple, Irwin and Ethel Ross, lived at 5526 Belmar Avenue in Southwest Philadelphia and taught at the Barry school at Fifty-eighth and Market Streets and the Longstreth school at Fifty-eighth and Willows, respectively. The couple, both graduates of the Normal School for teaching, were active at the Beth Am Israel synagogue on Fifty-eighth and Beaumont Streets. (Courtesy of Sara Pollock.)

The singing group known as the Brook Tones, who harmonized in the boys' bathroom of Overbrook High School during the early 1960s, became known as the sensational Dovels. Jerry Gross, son of a grocery store merchant, learned music from his father (who wrote songs) and dance while his mother played the piano. After moving to 7525 Brockton Road in Overbrook Park, Jerry met Mike Freda (Dennis), Arnie Silver (Satin), Len Borisoff (Barry), and Mark Gordesky (Stevens). Together they recorded their first hit record, "Bristol Stomp," and played at the Goodwill Fire Hall in Bristol, Pennsylvania. Today, Jerry is in the film industry. (Courtesy of Jerry Gross.)

HIT RECORDS:
★ Bristol Stomp
★ Hully Gully
★ Bristol Twistin Annie
★ Continental
★ You Can't Sit Down

As the years go by, friendships come to an end with time and death of many loved ones. Judaism lends itself to preserving one's good deeds and life by recalling the deceased once a year on the Hebrew anniversary of that person's demise with the lighting of a *Yahrzeit* candle and saying special prayers. Len Cobrin recalled his friend Ted Reinhart's past through his contribution to Philadelphia by hosting the first talk show on radio station WPEN in 1950. Pictured is Ted and Len at Arnold Stark's bachelor party. Stark was a public relation person for Bookbinder's Seafood restaurant. (Courtesy of Len Cobrin.)

113

Some photographs are worth a thousand words and yet are considered priceless. Thelma Cohen Bell recalled her fondest memories growing up and shared them in the introduction. The greatest memories are yet to be recorded, except for just this one of Thelma and her grandchildren in Florida. (Courtesy of Thelma Cohen Bell.)

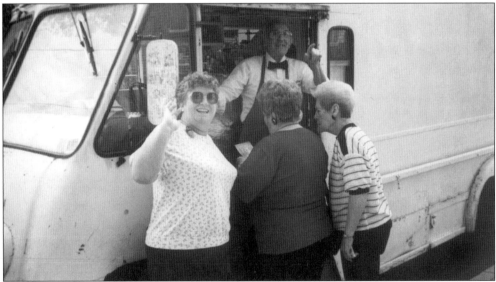

The huckster of yesteryear is gone but not forgotten. The memories of Jewish men with horse-drawn wagons selling products in the cobblestone streets of West Philadelphia is passé, but the idea of a mobile society in the 20th century did not stop Sid Cohen, the son of a kosher butcher in Island Road, from starting his own "corner market on wheels" in 1961. Sid was known as Butch to his customers in Darby Boro, Delaware County, where he worked five days a week from 5 a.m. until 8 p.m. providing customers with fresh eggs, fruit, produce, clothing, dry goods, toys, and good conversation as he put their purchases "on the books" in many cases without receiving money until their paydays. (Courtesy of Sid Cohen and his wife, Irene, who stuck by him all those years.)

Many adults had an eye for recording family events in the mid-1950s. Bob Kravitz, the grandson of Sam Glazer, the *shamus* (caretaker) for the synagogue, was considered a boy cantor in the 1950s, at age six. The path through life that Bob took led him to local television Channel 6 as the lead cameraman alongside popular local news anchor Marc Howard in the 1970s. Kravitz married his bus stop sweetheart after living in Wynnefield Heights near the television station. He and his wife, Susan, moved to Overbrook Park at 7302 Drexel Road. The neighborhood off Haverford Avenue was a magical place, where neighbors sat on their patios in the summer while the children played on the huge front lawns. Today, Bob sings and entertains guests at local restaurants. (Courtesy of Bob Kravitz.)

What is a Jewish boy like Alan Kurtz (formerly from 5922 Malvern Avenue in Wynnefield) doing in the Philadelphia police force? The answer for the son of June and Irvin Kurtz is simply this: leadership. As a young recruit stationed in the 18th precinct at Fifty-fifth and Pine Streets in West Philadelphia, he made the rank of detective by patrolling the beat on South Sixtieth Street. Alan checked in with Hymie's Jewish delicatessens for lunch. His order was a corned beef special with extra mustard. The rise of this great Jewish policeman to the rank of captain overseeing the K-9 and mounted horse patrolmen today holds a dual command, leading *Shomrim*, the Jewish police and firemen fraternal association, for fellowship and brotherhood activities. Kurtz appeared with Pres. Bill Clinton at a political rally inside Veteran's Stadium in the 1990s. (Courtesy of Alan Kurtz.)

Rabbi Ivan Caine grew up in Southwest Philadelphia at 5737 Florence Avenue and attended Beth Am Israel synagogue. It was here, in the 1940s, where he fell in love with the state of Israel. A knowledgeable Hebraist, Ivan Caine became an ordained rabbi, graduating from the Jewish Theological Seminary in 1957. The lasting affect of a good Jewish education at Beth Am Israel prepared Rabbi Caine to lead the former Romanian synagogue at Forth and Spruce Streets into a distinctive, revitalized Center City congregation known as the Society Hill Synagogue for the past 32 years. (Courtesy of Rabbi Ivan Caine.)

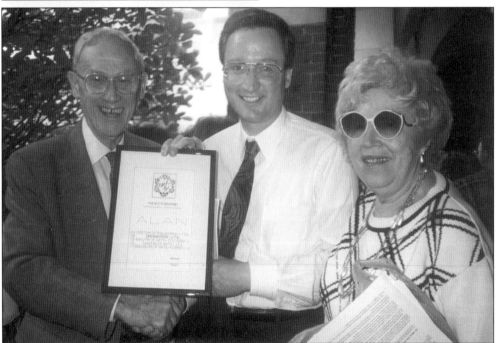

Rabbi Alan Silverstein, brother of Janice Silverstein Wilson, grew up in Wynnefield. Here he stands with his parents, Sol and Doris, as he proudly displays his doctorate from the Jewish Theological Seminary in 1992. Today Rabbi Silverstein, a past president of the international Rabbinical Assembly in the conservative movement, is the pulpit rabbi at Agudath Israel in Caldwell, New Jersey. (Courtesy of Janice Silverstein Wilson.)

Eleven
LIFELONG
FRIENDSHIP GROUPS

Childhood and teenage friendships are great to make and keep. The Jewish community of West Philadelphia rallied around their old neighborhood friends with zeal and a camaraderie that continues today. The acquaintances that these people have made persist to this very day in various forms. Whether neighbors, classmates, clubmates, or family members, they relied on each other over the years, making inseparable bonds. The images of these friendships are true treasures.

The Turbans, created by Larry Magid and his buddies right out of high school, frequented the Atlantic City shoreline and often went to Chelsea Beach. The group of young men ran around the hotels with towels wrapped around their heads—thus, the name. The group includes the guys and their wives and still party like the old days. (Courtesy of Larry Magid.)

The Boys of Parkside, who grew up in Koch-built homes on Parkside Avenue, reminisce over lunch in the dining room of the Bala Country Club on a regular basis. Guests are invited to give lively discussions of their life endeavors. The group consists of Bud Goldstein, Ed Bloom, Sid Sklaroff, Stan Tuttleman, Jerry Sklaroff, Don Baird, and Dick Erlich. (Courtesy of Sid Sklaroff.)

The 50th reunion of the 1941 graduating class of Overbrook High School was organized by Sylvia Memberg and other Jewish members of the class. Her cadre of workers, Jewish and non-Jewish, included Louis Starkman, Rabbi C. David Matt, Janet Applebaum, Gloria Belsh, Sylvia Boodis, Pat Curran, Irving Feldbaum, Golrose Foreman, Manny Kilstein, Evelyn Levick, Martin Lubrow, Evelyn Marks, Myrtle Raiken, Dr. Irv Smiler, Edith Weger, and Zelda Wolk. They held their orange and black reunion at the Twelve Caesars dinner theater and hotel. The group's 60th reunion celebration was held in 2001. (Courtesy of Sylvia Memberg.)

The Island Road synagogues ceased to exist in the 1950s and 1960s, but the members of the Eightieth and Eighty-fourth Street *shuls* held reunions for their old members at various location around the area, including in Atlantic City, at Jack's Delicatessen in Northeast Philadelphia, and at Kara's restaurant on the Benjamin Franklin Parkway. Even grandchildren are indoctrinated into the social group. Some of the members have since retired to Florida and congregate for old times' sake. Pictured are Joe Friedman, Milt Cilovitch (now Chase), Fred Greenberg, Steve Cohen, Gloria and George Koffs, Sam and Rina Silverstein, and Heshie and Delores Friedman. (Courtesy of Heshie Friedman.)

The Southwest Philadelphia Ex-Boys is a unique group of men who were pals in the old neighborhood near Sixtieth and Cedar Avenue and all attended the Bryant Elementary School and later West Philadelphia High School. The boundary for Southwest Philadelphia changed over time to include anybody living south of Market Street. Those within the border could choose to attend West Philadelphia High School in the 1940s. This association gathered for a reunion at the White Manor Country Club in Malvern in 1991 for day of golf, tennis, and lunch or dinner. Dr. Gerald Marks, Bob Reichlin, and Len Wasserman are driving forces of this group. (Courtesy of Dick Henry.)

Left: Best friends are easy to make when one is young. Bernie Toll and Bernie Glassman, from 5700 Stewart Street, enjoyed each other's company on a wooden bench in front of their newly built homes in the 1920s. Their attachment and friendship endured a lifetime, even though Bernie's parents, Rose and Joseph Toll, lost their dream house near Overbrook High School during the Great Depression and moved to another section of West Philadelphia. (Courtesy of Bernie Toll.) *Right:* Estelle Cooperstein poses with her best friend, Ruth Cutler. (Courtesy of Estelle Cooperstein.)

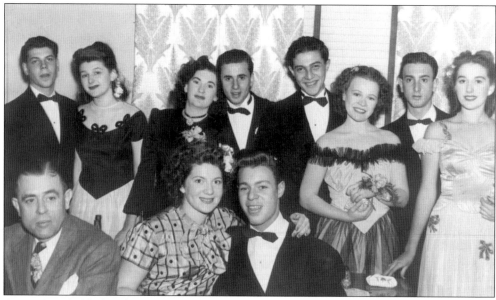

A party was held after the prom for the Class of 1944 at Bartram High School. These students had all previously attended the Wolf School at Eighty-second Street and Lyons Avenue. The children who attended this school came from all over the Island Road Jewish community. Often they thought they lived in another world, for their community in the Meadows was actually several feet below sea level, and thick fog rolled in nightly. By the time they arrived at school, the fog had cleared and it was a sunny day. (Courtesy of Frances Cohen Weiss.)

Left: Husband and wife Louis and Minnie Skaler operated a kosher butcher shop at Fortieth and Ogden for many years after they were married in 1913. The closeness of the couple was known to their three sons—Walter, Phillip, and Robert—from an early age. (Courtesy of Robert Skaler.) *Right:* A favorite pastime in Philadelphia, especially in the Fortieth Street and Girard Avenue neighborhood, was just sitting on the front wooden porches and watching life unfold in a daily flurry of activities. Mollie Greenberg's Bubba and Zada Yichael Cohen enjoy a peaceful day in the fall of 1939 on Pennsgrove Street. (Courtesy of Mollie Greenberg.)

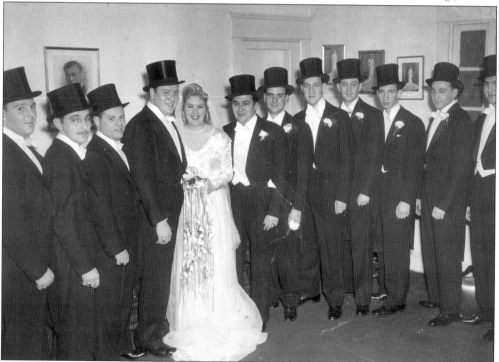

The boys in the neighborhood on both sides of Forty-second and Girard Avenue formed the Tau Phi Epsilon fraternity when they attended Overbrook High School in the 1940s. The friends' club included Bud Actman, Irv Shusterman, Jerry Shatzman, Leon Cohen, Lenny Rubin, Morty Herman, Harold Ratner, Norman Jaffe, and Danny Plenn. The club was founded after the wedding of Ray Jaffe and his wife, Sima. (Courtesy of Bud Actman.)

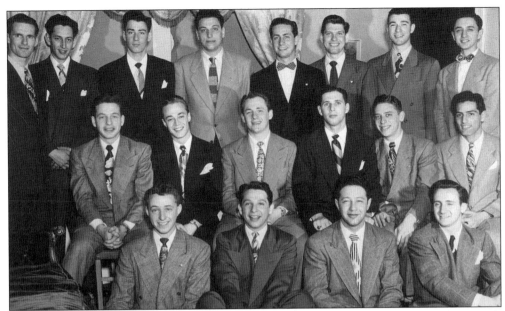

The creation of Jewish fraternities in Philadelphia dates back to the second decade of the 20th century, when high school groups formed for the upper-grade students. The continuation of a fellowship spirit played an important role in the development of Key Beta Sigma (KBS) at the Hamilton Elementary School in 1938. The junior fraternity continued past the high school years, and the boys stuck together as friends. The members in this photograph include Alan Rogoff, Joe Rosenfeldt, Frank Wagner, Rudolph Brooks, Sidney Silverman, Stan Cohen, Alan Renschler, Berel Caesar, and Eli Printsker. (Courtesy of Stan Cohen.)

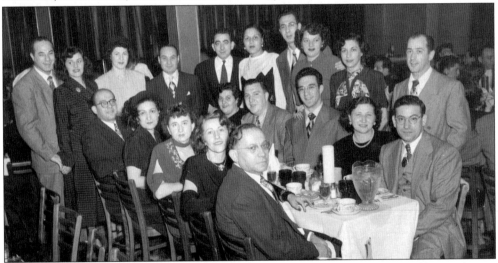

Cousins' clubs were popular in the 1940s and 1950s. Whole neighborhoods could boast of many uncles and aunts with children who were related to one another. The cousins socialized and went out to sporting events to enjoy each other's company and conversation—before the advent of the television set. Bella and Reds Pollan from Sixtieth and Christian Street joined Gladys and Harry Pollan, Alex and Helen Magid, Evelyn and Harry Marshall, and Eileen and Marty Pollan at Himmelstein's restaurant, downtown at Fifth and South Streets, for regular brunches. (Courtesy of Larry Magid.)

Jewish involvement in organizing high school reunions is legendary in West Philadelphia. The alumni lists read like a who's who and can provide a real sense of Jewish migration paths throughout the Philadelphia region. This photograph captures the West Philadelphia High School Class of 1946, which held its 50th reunion in 1997 at the Sugarloaf Conference Center in Chestnut Hill. More than 95 percent of the attendees were Jews, including Martin Borowsky, Jerome Felscher, Howard Fishbein, Joseph H Graboyes, Allene Hollander Solomon, Anita Levin Kuptsow, Janet Lonker Simon, Norman Lubroff, Albert Nipon, Thelma Saget Shorr, and Bertram Samuels. (Courtesy of Anita Levin Kuptsow.)

The Park City West Boys (from the pocket of streets bounded by City, Belmont, and Conshohocken State Roads) lived in the shadow of the first all-electric high-rise apartments. Many of the Jewish residents there had two or three children. Some of these were buddies David Lipkin, Murray Levin, Richard Taxin, and David Grunfeld—all of whom lived on Forty-sixth, Forty-seventh, Parma, and Lenapi Streets. David Lipkin's father and grandfather operated the famous Gold Medal Bakery at Thirty-ninth and Cambridge Streets, known citywide for its rye bread. (Courtesy of David Lipkin.)

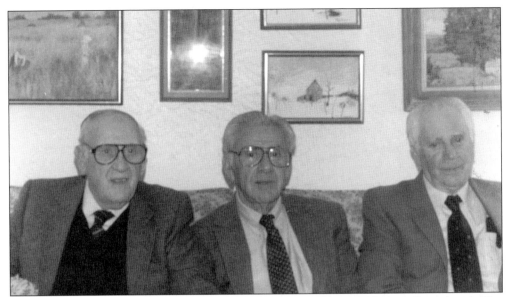

These three *boychicks*, Raymond, Nathan, and Jack, are siblings of Sidney Fingerhood. The brothers were all born in the 1920s and lived at 3844 Pennsgrove Street. The Fingerhood boys wore hand-me-down clothes and lived in a house lighted by gas and kerosene until their home was electrified in the mid-1920s. This family, like countless others, lost their home when failing banks began to call in their mortgages, yet the Fingerhoods remained in the Fortieth and Girard neighborhood by renting properties. Today, Sidney misses the company of his two brothers, Jack and Raymond, who have since passed away. (Courtesy of Sidney Fingerhood.)

The West Philadelphia Boys Club met on the streets in the neighborhood around Fortieth Street and Girard in the 1940s. The boys remained friends throughout their lives. They can still recall their idol, heavy weightlifting champion David Mayer, a neighborhood boy who qualified for the 1936 Olympic games in Berlin, Germany, though not allowed to compete because he was a Jew. The surviving club members included Herbert Yudenfriend, Len Barkan, Fred Pearlstein, Arthur Cherry, Martin Smith (who are all pictured), Eli Cotler, and Walter Gothberg. The deceased members were Seymour Kipnis and Louis Lubin. (Courtesy of Len Barkan.)

These Beeber Junior High School girls—Janis Hopkins Jurnovoy, Harriet Greenblatt Contract, and Toby Gorchov Lerner—came from different neighborhoods but met and became close friends in the 1950s. All three won a faculty award and were photographed together. They later attended their first bar mitzvah at the Wynne Caterers hall in Wynnefield. From there the girls went on dates and were often seen at Horn & Hardart's restaurant or at the United Synagogue Youth dances held at Har Zion Temple. The girls really enjoyed their childhood and capped it off at the Green Lane camp, above Collegeville, Pennsylvania, before attending Overbrook High School. The girls celebrated their lifelong journey in July 2000 at their 40th high school reunion. (Courtesy of Harriet Greenblatt Contract.)

Inseparable girlfriends from the January 1953 graduating class of West Philadelphia High School include Barber Nager Friedman, Mimi Shapiro Dash, Molley Crasner Freedman, Evy Blank Lessin, and Harriette Muller Goldenberg. They all lived within blocks of each other near Fifty-ninth and Ellsworth Streets. Barber Nager became Miss Pennsylvania right after high school in the Miss America Pageant. The ladies have come to support each other in time of pain and sorrow. Evy died from ovarian cancer in 1991, and her friends rallied to create the Evy Lessin Fund for ovarian cancer research at Philadelphia's premier Fox Chase Cancer Center. (Courtesy of Molly Freedman.)

125

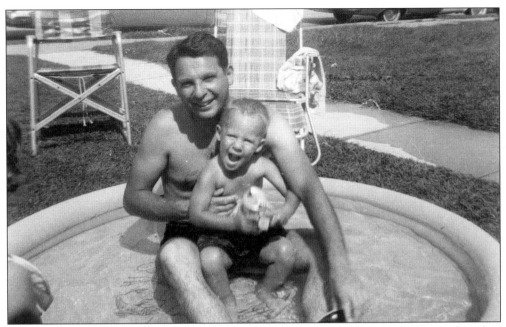

Sometimes parents avow of themselves as best friends to their children, but we know that they just want to be children themselves all over again. Stanley Cohen moved to Overbrook Park in the 1950s to create a better lifestyle for his family. The times were great, driving new-looking cars with fins and living in brand-new Warner West brick row houses with lawns big enough to have pool parties. Stan and his son David bathe in the warm summer sun in their own vacation getaway only steps from the patio. Gosh, how we miss those days! (Courtesy of Stan Cohen.)

Fellow Overbrook Park and Haverford Avenue merchants Edward Moskow and Sam Barson shared the same address at the shops on Haverford and City Avenues and enjoyed each other's company. Ed Moskow received his training at the Tyler School of Art and migrated with his wife, Rosalie, to Overbrook Park in the early 1950s to raise three children, Lee, Susan, and Jan. Today, Moskow (of blessed memory) is remembered as a great father. His children Lee and Susan operate Moskow Photography Studios in the same location. (Courtesy of Susan, Lee, Jan, and Roaslie Moskow.)

The crossroads community of merchants at City Line and Haverford Avenue is composed of shops that sustain the present Jewish community of Overbrook Park. This community is the main reason why the area has grown in the last 10 years. Access to the suburbs is nearby, but businesses such as New York Bagels, Main Line kosher meats, R & R produce and fish, the Best Cake Bakery, and Shalom Pizza all give their clientele a taste of Philadelphia's old Jewish neighborhoods. There is, however, one important difference between these stores and any group of Jewish merchants who existed before them—they all close for the Jewish Sabbath. All the shops are under the supervision of the Orthodox Vaad of Philadelphia. R & R proprietor Robert Bender (a native of Wynnefield) and his wife, Ruth, serve the best smoked fish in the city.

Pizza is a mainstay of the American diet, and its popularity has risen over the last 25 years. One could ask, "A Jewish pizzeria?" and the answer would be a resounding yes. Former owners Sam and Rachel opened Shalom Pizza in anticipation of offering what every other Philadelphian loves—a slice of hot pizza. Yet this store is different because their ovens are cold on Friday nights so that the owners may enjoy the company of their families in their homes as they welcome the beginning of the Jewish Sabbath. The ingredients used at Shalom Pizza are completely kosher and vegetarian. The store, in keeping with Jewish tradition (like its counterpart Best Cake Bakery around the corner), is closed during Passover, when no leavened bread is eaten as prescribed in the Bible.

Allen Meyers, a big *nosher* (snack lover), can not resist going by any bakery without stopping in and trying some of his favorite desserts. This location is Jan Moskow's Best Cake Bakery, a *shomre shabbas* establishment in Overbrook Park on Haverford near City Line Avenue. Allen is holding his favorite, a wine cake made of a small yellow sponge cake with raspberry jelly and flakes of real coconut attached to it by a thick layer of creamy butter fudge icing. A trivia lover, Allen wants to know from anyone in the community the origin of the wine cake.

Meyers's mother, the former Esther Ponnock (of blessed memory) and the daughter of Louis and Rose Ponnock, often told Allen, "You can not live in the past, but you must learn it in order to explain the details to your children, who will want to know all about it someday."

You may contact Allen Meyers at 11 Ark Court, Sewell, New Jersey, 08080. Phone: (856) 582-0432. Fax: (856) 582-7462. E-mail: ameyers@net-gate.com. Web site: www.jewishphilly neighbors.com.

A Lifetime Avocation

This volume is only a snapshot that validates the existence of Jewish life in West Philadelphia throughout the 20th century in the seven distinctive neighborhoods and sections that were home to thousands of Jewish people west of the Schuylkill River. This is a tribute to the rise and decline of Jewish neighborhoods, with an emphasis on the development of the neighborhood synagogues throughout Philadelphia over the last 120 years. The author assisted graduate students in the Urban Studies Department at the University of Pennsylvania over the last 20 years through the supervision of Dr. Carolyn Golab, who encouraged and helped to define this great contribution as an independent research project in 1981. Meyers's own thesis that Jewish neighborhoods developed at the end of street car lines is proof positive of the development of West Philadelphia as a viable place to conduct Jewish life. However, he has learned that, unlike other parts of Philadelphia, each section of West Philadelphia exhibited signs of complete independence from each other as they developed special Jewish identities. The sovereignty of each community is unlike any section of Philadelphia, and its character was determined by previous ethnic groups and their concern for boundaries. Only the advent of the north and south trolley car lines and the automobile helped to break down the provincial nature of each neighborhood regardless of inter-family ties. At no time, however, did the various neighborhoods unite and feel as one entity. The complete three-volume work entitled *Philadelphia's Old Jewish Neighborhoods* will be sponsored and deposited at the Annenberg Judaic Studies Library at the University of Pennsylvania in late 2001.